STORYTELLING
PORTRAIT PHOTOGRAPHY

How to Document the Lives of Children and Families

Paula Ferazzi Swift

AMHERST MEDIA, INC BUFFALO, NY

I dedicate this book to my husband Chris who believed in my talent as a photographer when we first met in college as communications majors. He stood behind me through my career as a photojournalist and supported my decision to open a child and family portrait photography studio. I would like to thank him for being there for me every step of the way. I also would like to thank my three boys Ryan, Trevor, and Logan for being my daily inspirations and for dealing with my camera from the moment they entered this world. If it weren't for them, I would not be the photographer I am today.

Paula Ferazzi Swift

AUTHOR A BOOK WITH AMHERST MEDIA!

Are you an accomplished photographer with devoted fans? Consider authoring a book with us and share your quality images and wisdom with your fans. It's a great way to build your business and brand through a high-quality, full-color printed book sold worldwide. Our experienced team makes it easy and rewarding for each book sold—no cost to you. E-mail **submissions@amherstmedia.com** *today!*

Published by:
Amherst Media, Inc., P.O. Box 538, Buffalo, N.Y. 14213
www.AmherstMedia.com

Publisher: Craig Alesse
Senior Editor/Production Manager: Michelle Perkins
Editors: Barbara A. Lynch-Johnt and Beth Alesse
Acquisitions Editor: Harvey Goldstein
Associate Publisher: Kate Neaverth
Editorial Assistance from: Ray Bakos, Rebecca Rudell, Jen Sexton
Business Manager: Adam Richards

ISBN-13: 978-1-68203-148-3
Library of Congress Control Number: 2016945445
Printed in The United States of America.
10 9 8 7 6 5 4 3 2 1

www.facebook.com/AmherstMediaInc
www.youtube.com/AmherstMedia
www.twitter.com/AmherstMedia

Contents

About The Author

Image by Christopher Swift

Paula Ferazzi Swift, M. Photog., Cr., CPP, is a Master Photographer, Photographic Craftsman, Certified Professional Photographer, and an international, award-winning photographer working in the Boston metropolitan area. She specializes in the art of capturing images of children, their families, and relationships of couples. Paula's professional photography studio is in Sudbury, MA.

Photography has been Paula's passion ever since she was a child, as she was the subject of many photos taken by her older sister, a photojournalist. She received her first manual camera and introduction to its magical world at age thirteen. Later, she received two college degrees in photography. Paula received an A.S. in Visual Arts-Photography and B. S. in Communications Media-Photography. She worked as a staff photojournalist at the *Worcester Telegram & Gazette* for ten years. After having had her first son in April 2003, Paula decided on a new path into the world of children and family portraiture.

Paula is a nationally-recognized photographer for her published work in newspapers and magazines. She has been nominated for and won several national and international awards including the recognition of her and the photography staff at the *Worcester Telegram & Gazette* as finalists for the 1999 Pulitzer Prize in Feature Photography for their coverage of the Worcester Warehouse fire that killed six Worcester, MA, firefighters. Paula has won National Press Photographers Association and New England Associated Press Editors Association awards for her photojournalism work, as well as local advertising awards for her photography. She is a member of such profes-sional organizations as the Professional Photographers of America, Professional Photographers Association of Massachusetts, and American Society of Photographers.

In 2009 Paula was the recipient of the Hallmark Award for best color portrait. She was also presented the Kodak Gallery Portrait Award for the highest scoring portrait print, judges choice ribbon, and three blue merit ribbons at the Professional Photographers Association of Massachusetts annual print competition, 2010 through 2016. Her work was recognized and awarded the highest honor of Loan Collection and General Collection at the Professional Photographers of America International Photographic Competition. Recently, Paula Swift Photography was featured by CBS Boston as one of the best Boston Family Photographers. Paula continues to grow her craft by attending professional photography seminars and workshops, and she is currently sharing her knowledge by speaking at seminars and authoring books.

Her work has been published in a variety of publications, including *The Boston Globe, The Boston Herald, The Los Angeles Times, The New York Times, The Washington Times, Time, Newsweek, USA Today, and Esquire.*

In 2015, Paula Swift began teaching other photographers about newborn photography and storytelling portrait photography. She also speaks throughout New England on her photojournalism experience and how she incorporates that unique career into her everyday portrait photography work.

Paula, who grew up in Longmeadow, MA, currently lives in Framingham, MA with her husband Chris and their three sons Ryan, Trevor, and Logan—her inspirations.

www.paulaswift.com
www.facebook.com/PaulaSwiftPhotography
www.twitter.com/PaulaSwiftPhoto
www.youtube.com/user/PaulaSwiftPhoto

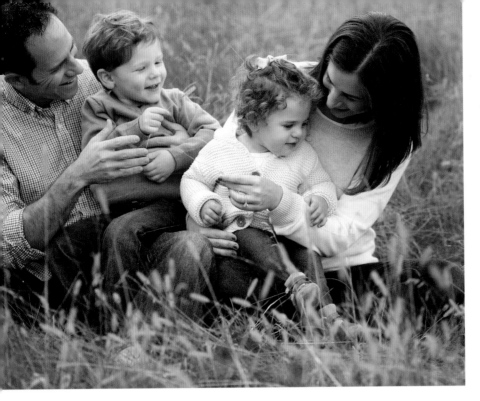

field and had the big brother who was three years old try and tickle her as mom and dad did, too. What worked perfectly was when big brother took a long piece of grass to engage his little sister. Everyone was smiling and giggling in the moment. I love that they weren't looking at the camera during this family moment.

Time to Warm Up ⇧

A family of four, with a three-year-old and one-year-old, hired me to photograph them on a fall afternoon. The little one-year-old girl needed some time to warm up to me. So I started with the family sitting down in a

Late afternoon light was filtered by light cloud cover, which was perfect for this open-sky session.

SPECS > Canon Mark III with 135 2.0 lens at 1/500 second, F3.5, and ISO 400.

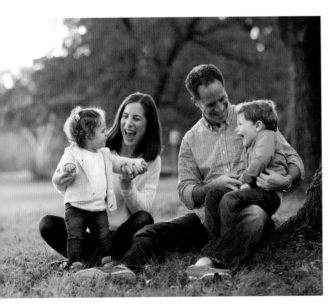

Capturing Genuine Smiles ⇐

Once the little girl and family were comfortable with me, laughs and smiles were abundant during their fall session. We had about an hour of nice light left. The sun peeked through the back of a Japanese maple, adding warm fall colors on a day when the season's foliage had not quite turned in this New England location. I love capturing genuine smiles that families share during their sessions.

SPECS > Canon Mark III with 135 2.0 lens at 1/500 second, F3.5, and ISO 400.

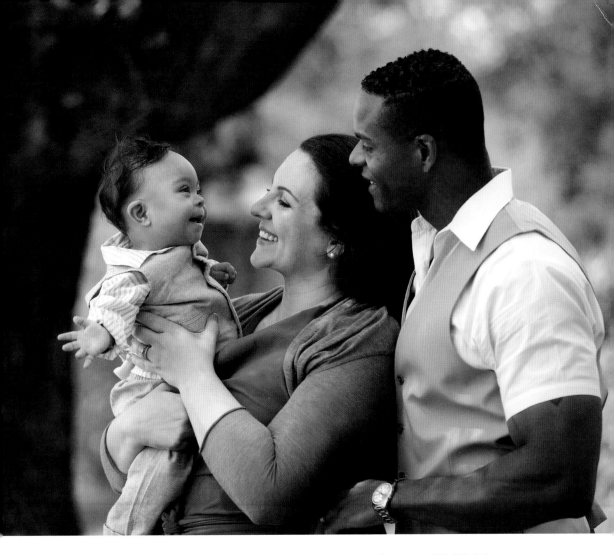

Morning Light Filtered 🔼

This family returned to celebrate their son's one-year birthday. I had photographed him for his newborn session, so it was great to see him outdoors and to see him grow up into a little boy. This image was taken in May when the leaves were nice and green, and the morning light was filtered by the tree cover. I had favorable open sky behind me helping to light the family. Mom and dad just looked and talked to their boy as he smiled away in his mom's arms. The eye contact that mom and dad had with their son was beautiful at this moment.

SPECS > Canon Mark II using a 70-200 II IS at 160mm, f/4, ¹/₂₅₀ second, and ISO 250.

I had favorable open sky behind me helping to light the family.

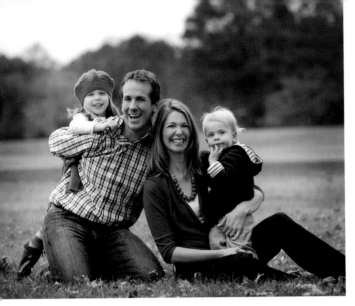

son and their daughter came running up behind dad. It was a moment in between moments, but they all looked at my camera at the same time as I fired away to capture those authentic expressions.

It was an overcast morning with open sky behind them and in front of them for natural fill.

SPECS > Canon Mark II using a 70–200 at 150mm, f/4, ¹⁄₆₄₀ second, and ISO 200.

Genuine Moments

I love to sit young families down on the ground during their sessions whenever possible. This helps for the younger children to feel more at ease and not as nervous when I'm photographing them. Especially when it's their first session with me. They soon learn to trust me, as mom and dad are smiling and so is their older sibling. This session was one of those instances. Big brother had been photographed by me years before and seemed very comfortable with me; his brother definitely had some reservations. However, once they sat down and mom raised him up in the air, his brother tickled his belly, everyone started laughing and he began to smile and have fun. He forgot I was there, which is important so that I can capture those genuine moments during my family sessions.

They are sitting under tree cover on an early fall morning with open sky in front of them for fill. I laid down on my belly a bit to get lower than them.

SPECS > Canon Mark III using a 135mm, f/3.5, ¹⁄₅₀₀ second, and ISO 400.

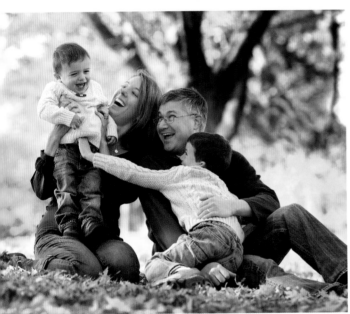

Make the Session Fun

I first met this family when their little girl was just four months old. Fast forward a few years and she is a big three-and-one-half-year-old sister to her little eighteen-month-old brother. These ages can be tough if you try to pose them. I made it an enjoyable session by letting them have fun. I sat the parents down in the grass as mom held her

Formal Portrait in the Park ⬇

It was a beautiful fall morning when I met this family for a formal portrait session in the Boston Public Gardens. They had nearly-two-year-old twins who were on the go. The foliage was a great combination with the colors they wore. Mom and dad would lift each child up as they would try to run toward the lagoon. I followed them throughout the location, capturing them as they carried on. This captured moment was great as the little girl peered over at me and smiled. The sky was overcast with light reflected in from a nearby building and the pond-water surface.

SPECS > Canon EOS 5D Mark II using a 70–200mm, f/2.8, 1/500 second, and ISO 400.

Photojournalism Skills ⇒

I use my photojournalism skills at every session, waiting for those unexpected moments like this one. Dad had brought his trombone to the session and started playing it at the Boston Public Gardens, which if you have ever been to the garden, is not unheard of. Lots of musicians play throughout this location. His twins wanted to be near dad and to touch the trombone, so mom kept on trying to hold them back gently. I loved this moment as it appeared for just a few seconds.

SPECS > Canon Mark II using a 135mm, f/4, 1/500 second, and ISO 250.

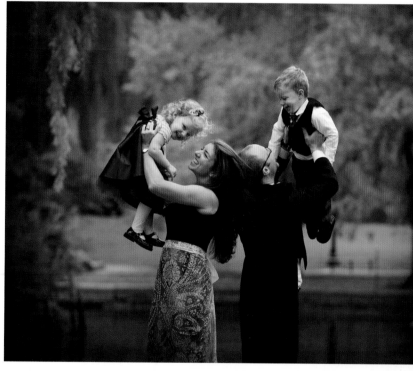

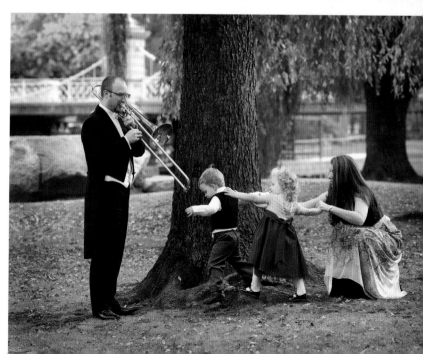

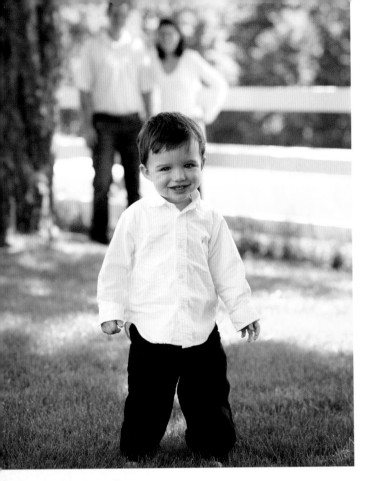

Foreground to Show Who Rules ⇐

I photographed this family with their one-year-old son who loved to show me around their family farm. I wanted to show how he was the ruler of the family, in a nice way, and created a layer by placing him in the foreground with his parents smiling in the background. They stood under green tree cover, and I used the sky and house behind me for a nice natural fill.

SPECS > Canon Mark II using a 70–200mm at 85, f/3.5, 1/500 second, and ISO 250.

This is a great moment, especially for a new walker.

Document a Fleeting Time ⇐

After capturing him looking my way, I had his mom and dad call him so he would walk back their way. This is a great moment, especially for a new walker. It documents that fleeting time from toddler to boyhood—a stage which passes in the blink of an eye, and parents forget how quickly it happens. He was still under tree cover, so my exposure stayed the same.

SPECS > Canon Mark II using a 70–200mm at 85, f/3.5, 1/500 second, and ISO 250.

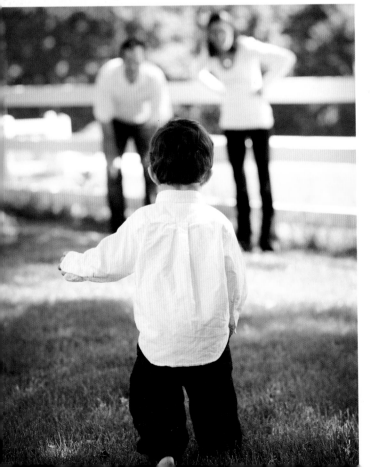

Multiple Ages ⇒

When it comes to photographing families with multiple children and age ranges, it can add a degree of difficulty. Do you want them all looking at the camera or looking at each other? I had been photographing this family since their two older girls were just babies. They knew my journalistic style of photography and knew what to do. I had them sit near the top of this old bridge as I got down a little lower than them. Then I had them cheer for their one-year-old son and only brother. He was thrilled by this and started clapping himself. I fired off a few frames, but this image is the one—kids clapping and smiling, as parents looked at them proudly. It was photographed on an overcast, early summer morning. No light modifiers used.

SPECS > Canon Mark II using a 70-182mm at 182, f/4, ¹/₅₀₀ second, and ISO 200.

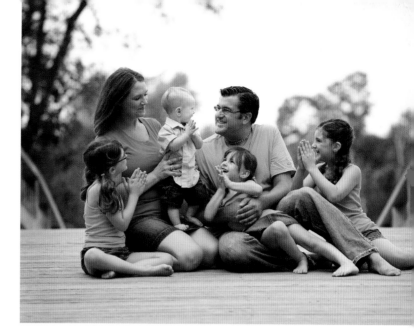

Interacting and Trusting ⤵

Parents interacting with their child is important in order to get the youngster to trust me before I start to photograph them solo. I always start with the whole family first so this trust can be gained. This little girl didn't need much prompting, as she was easy to get to smile as dad handed her a small yellow wildflower he found in the field they were sitting in.

SPECS > Canon 5D Mark II using a 70-200mm at 95, f/3.5, ¹/₅₀₀ second, and ISO 320.

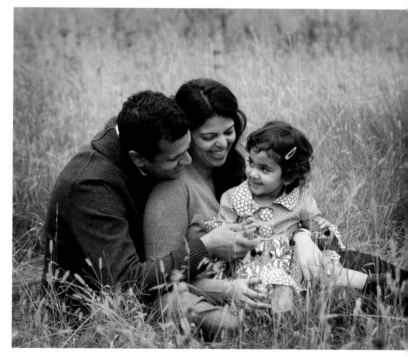

A Sweet Moment ⬇

I met this family on a late spring morning at the Boston Public Gardens to photograph the family with their young son. He wasn't quite walking yet and had a little stranger fear of me at first. Shy children are very common, and when you bring out that long lens it can be scary to them. I started photographing mom and dad holding and talking to him, so he was aware of my camera even though I stepped back. At this moment dad held him, mom grabbed his hand, and he looked over at her. Such a sweet moment.

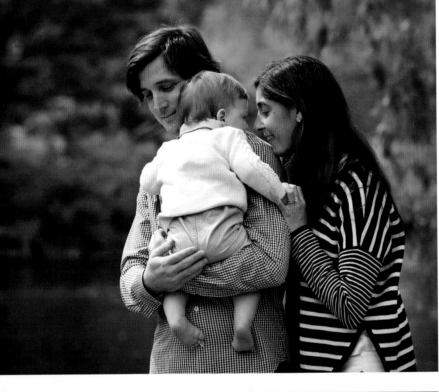

SPECS > Canon Mark III using a 70-200mm at 110, f/3.5, 1/80 $^1/_{800}$ second, and ISO 250.

Filter through the Trees ↗

He soon started to warm up to me, and mom and dad watched as he started smiling my way, while still in the comfort of dad's arms.

Sun is filtered through the trees with some fill from open sky behind me.

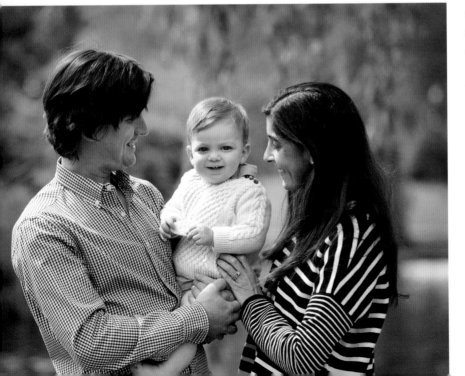

SPECS > Canon Mark III using a 70-200mm at 150, f/3.5, $^1/_{800}$ second, and ISO 250.

Get More
in the Foreground ⇨

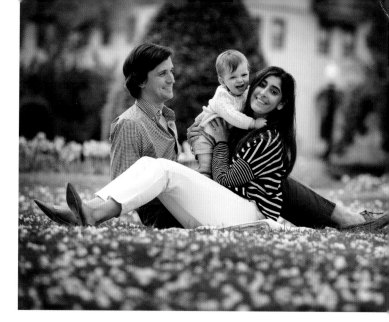

I positioned the family on the
ground for this next portrait. Their
son was now enjoying the session,
and I loved seeing all the white pet-
als on the grass that had fallen off
the trees. The beautiful tulips in
the background added a nice touch
of color. I laid down on my belly
to get more of the foreground in
the frame and to get a little lower
than them. Just then, the little
boy started to giggle and smile as
mom looked at the camera and dad
smiled at them. He was tugging on
his mom's hair, and he was being
so cute at the same time.

SPECS > Canon Mark III using a 70–
200mm at 170, f/3.5, $\frac{1}{800}$ second,
and ISO 250.

Children Grow So Fast ⇨

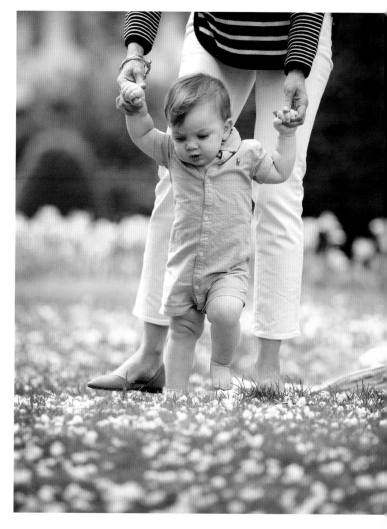

We ended their session with mom
walking him barefoot through
the grass and petals at the public
gardens. I find these moments so
important to photograph for mom
and dad. Children grow so fast that
to have these memories in photo-
graphs will make these moments
last a lifetime.

SPECS > Canon Mark III using a 70–
200mm at 200, f/3.5, $\frac{1}{800}$ second,
and ISO 250.

Layering the Subjects ⏷

Layering my clients and their children as I photograph is something I do a lot during family portrait sessions. It adds an element of storytelling without any action being in the photograph. These two brothers, who I believe were at least ten years different in age, were placed about ten feet in front and to the right of their parents. Mom and dad in the back left watched as their two boys smiled toward me. The way the youngest boy positioned himself in his brother's legs was so cute. It made for a fun portrait.

SPECS > Canon EOS 5D Mark III using a 70-200mm at 102, f/4, 1/500 second, and ISO 250.

Apply Filter to Desaturate ⏎

Layering is useful when a child wants to use one of your props during the session. I loved this moment as the youngest of three boys road the tricycle in my direction. The rest of the family walked behind on my favorite path, as the sunset started to filter through the trees on a warm, late-spring afternoon. He rode to that sweet light spot at the perfect moment. I processed this image in Photoshop by applying a filter, which took a little color out, giving it an old-time feel.

SPECS > Canon EOS 5D Mark III using a 70-200mm at 70, f/3.5, 1/500 second, and ISO 320.

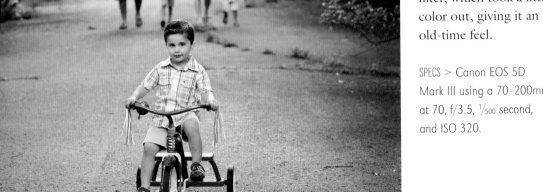

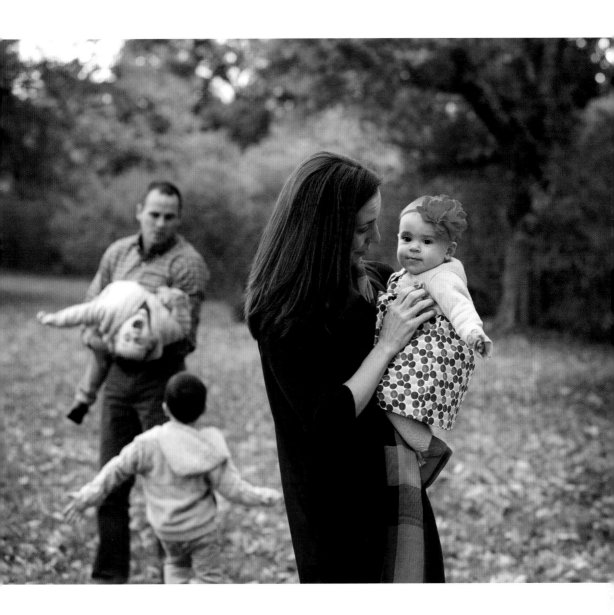

Background Action ⇪

This layering concept can be used with a parent and child as well. It was a cold and overcast October afternoon, so to keep everyone warm it was one of those shoot-as-fast-as-you-can family sessions. The foliage was in its prime, too. I was aiming to photograph mom with her new little girl who was about six-months old. Suddenly in the background, her two sons came running toward their dad.

I framed them in the shot instead of zooming in on just the mom and daughter. This is how families are. It was just perfect.

SPECS > Canon EOS 5D Mark III using a 70-200mm at 70, f/3.5, $\frac{1}{500}$ second, and ISO 500.

The Bag of Tricks ⇩

This little girl warmed up to me quickly during their session and had been playing with one of my faux apples that I usually bring. The suitcase she is sitting on was full of them.

It's my bag of tricks. Kids don't know about them, unless I need to bring them out. She was teasing me—as if she was going to take a bite out of the fake apple, and I photographed her while in the path.

SPECS > Canon EOS 5D Mark II using a 70-200mm at 160, f/3.5, ¹/₅₀₀ second, and ISO 400.

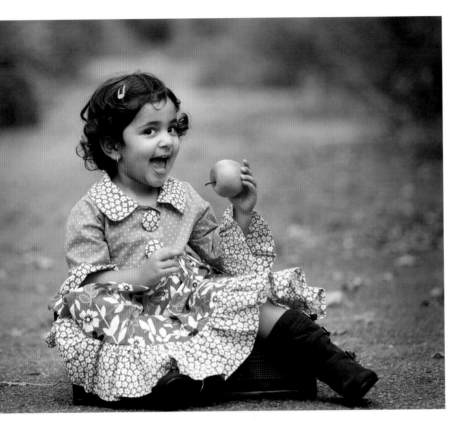

A Moment of Looking ⬈

I photographed these three sisters during their mom's outdoor maternity session. It was a mid-summer session in the afternoon under the cover of trees. As I began to pose them, they started to look at one another while getting into their position to smile at me. I loved this moment as the middle sister looked my way and the older and younger two sisters looked toward each other.

SPECS > Canon EOS 5D Mark II using a 70-200mm at 175, f/3.5, ¹/₅₀₀ second, and ISO 250.

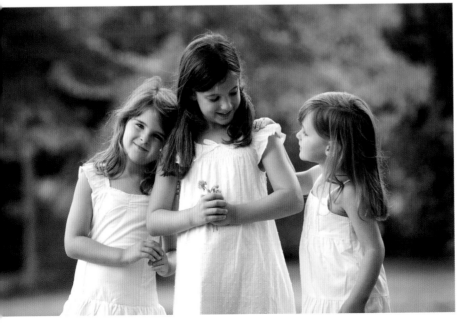

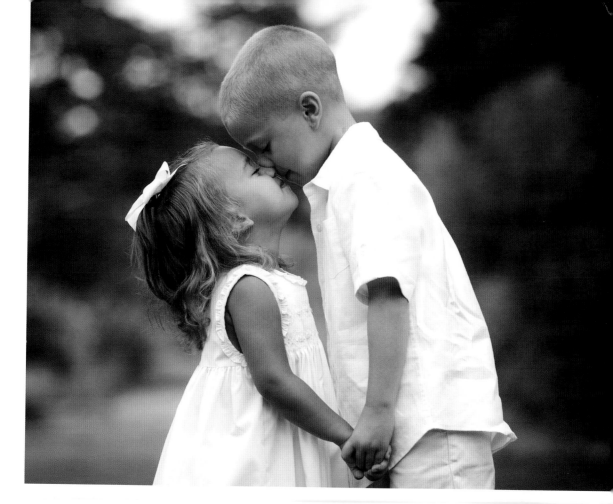

Eskimo Kisses ⇪ ⇨

This is a brother-and-sister session where the parents were not included. They had been Eskimo kissing, which was perfect for the younger sister. This session was particularly fun as they did this without prompting. I zoomed in on them as they touched noses.

Then I zoomed out to show how little they were at the time, just about four years old and six years old. Another sweet series of moments captured during their summer session on an overcast day.

SPECS > Canon EOS 5D Mark II using a 70-200mm at 150, f/3.5, ¹/₈₀₀ second, and ISO 200.

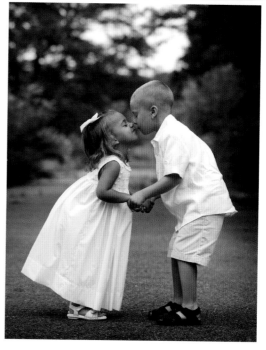

Adorable Twins ⇐

Adorable set of brother and sister twins. They were so cute and leaned up against this tree perfectly posed and looked my way. The light was filtered coming in from behind them during this October session.

SPECS > Canon EOS 5D Mark II using a 70-200 II IS 2.8 at 182mm, f/3.5 second, $1/500$ second and ISO 320.

Positioning for the Background ⇐

Just like that, out of no-where, the giggles start. I didn't stop shooting through these, because they added an amazing element to the session. It became fun and more like a day at the park. I moved just a bit to the side to get the tree they were standing near out of the frame, and then zoomed out to include the gorgeous background.

SPECS > Canon EOS 5D Mark II using a 70-200 II IS 2.8 at 125mm, f/3.5 second, $1/500$ second and ISO 320.

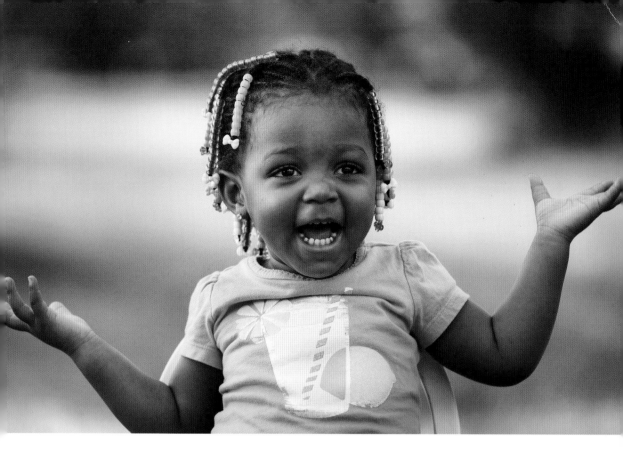

A Sense of Humor ⇪

This one-year-old definitely had a great sense of humor laughing, and using her hands to express her happiness throughout the session. She just sat on one of my little studio chairs that we had brought to the park and had a blast.

SPECS > Canon EOS 5D Mark II using a 70–200 II IS 2.8 at 200mm, f/3.5 second ¹/₅₀₀, second and ISO 250.

Not Looking at the Camera ⇒

Her personality shined as she stood on a crate and danced to one of her favorite songs. Not looking at the camera is okay, especially during a moment like this.

SPECS > Canon EOS 5D Mark II using a 70–200 II IS 2.8 at 80mm, f/3.5, ¹/₅₀₀ second and ISO 250.

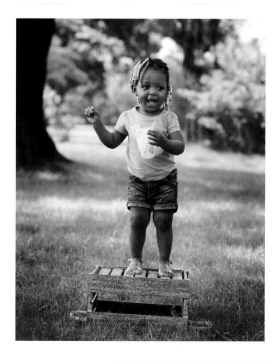

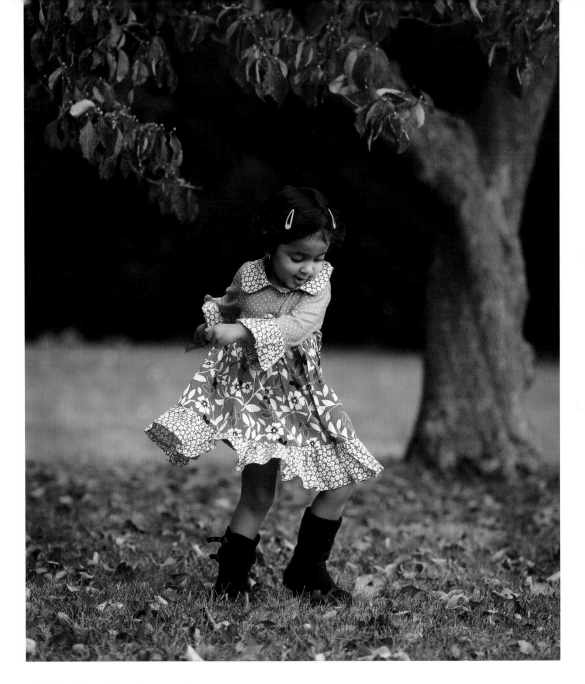

End-of-Session Dance ⇧

I love watching my little clients dance. This little girl was on her way back to her car at the end of the session when she stopped to twirl and dance under this tree. First of all, she and the tree were a beautiful color combination, and to watch her dance happily at the end of the session was heartwarming.

Parents loved this too and it reminds me never to put that camera away until they are driving away from the session. I would have missed this moment if my gear was put away already and I had left before they had.

SPECS > Canon EOS 5D Mark II using a 135mm 2.0 lens, f/2.8, $^1/_{500}$ second, and ISO 400.

Ring Around the Rosie ⇒

The song *Ring Around the Rosie, a Pocket Full of Posies* is so popular with my toddler clients, and they love to dance around to it. Bring on the music, especially when there are two toddlers involved. Mom dressed them in these adorable tutu dresses for the on-location session on this warm summer day.

SPECS > Canon EOS 5D Mark II using a 70–200mm at 180, f/4, $^1/_{1250}$ second, and ISO 200.

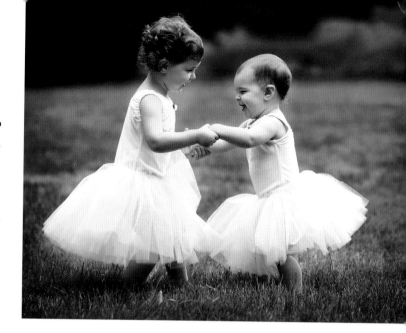

Song Brings Them Back ⇒

Ring Around the Rosie works great when you lose a sibling's interest in a photography session. Gather the older siblings to start it and you will soon have everyone back in the game. At this time in the session, the big sisters were dancing around their one-year-old sister when she had decided she was done with her participation in the session. The framing of them under the big tree with all the golden foliage all fell into place.

SPECS > Canon EOS 5D Mark II using a 70–200mm at 170, f/3.5, $^1/_{500}$ second, and ISO 320.

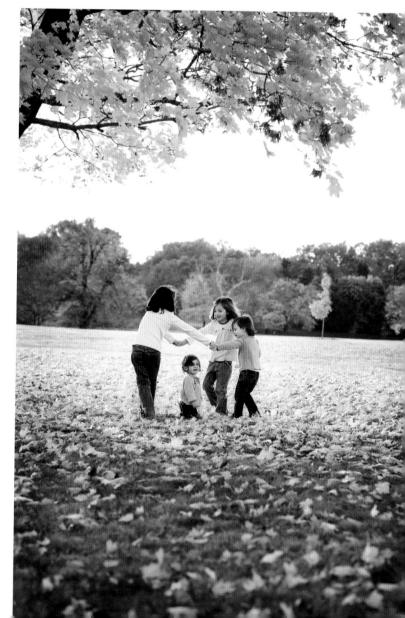

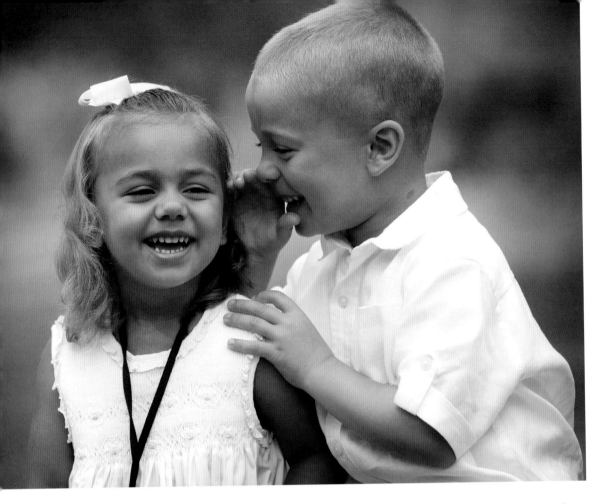

Have Them Whisper Something ⇧

Children are playful, and they love to do fun things in front of the camera. They can ignore the camera after a while unlike most adults. Even if it take a little prompting. One of my favorite prompts is to have one of the siblings whisper to the other something really funny.

SPECS > Canon EOS 5D Mark II using a 70-200mm at 200, f/3.5, $^{1}/_{800}$ second, and ISO 200.

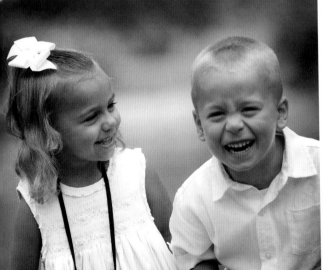

Funny Secrets ⇐

Watch the laughter unfold. Usually the child hearing a funny secret laughs quickly, but in this case the teller of the secret laughed harder and faster.

SPECS > Canon EOS 5D Mark II using a 70-200mm at 200, f/3.5, $^{1}/_{800}$ second, and ISO 200.

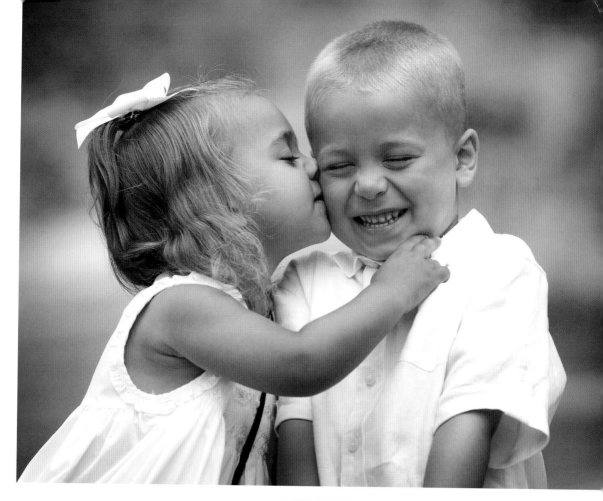

A Kiss for Him ⬆

However, what big brother didn't know is I had whispered to his little sister for her to kiss him on the cheek after he told her the secret. She executed this perfectly.

SPECS > Canon EOS 5D Mark II using a 70-200mm at 200, f/3.5, $1/800$ second, and ISO 200.

A Fun Storytelling Series ⇨

His reaction was great and added a fun storytelling series of images from their sibling photography session. This took place on a warm summer morning.

SPECS > Canon EOS 5D Mark II using a 70-200mm at 200, f/3.5, $1/800$ second, and ISO 200.

A Red Wagon ⬆

I love to use my red wagon. It's one of those very popular wagons many of us had as kids. For some reason, the color, being able to sit in it, pull it, or push it guides kids into the photography session. I use it to bring my gear in to most sessions, but only use it if it's requested or the child needs it. Once you get them in it, it's hard to get them out of it. The smiles are worth it though. Just like these two gave me as they sat and had fun together. The older brother was more

into running and discovering all the sticks he could find. There are only so many boy-with-a-stick portraits you can take. The wagon was a saving grace for this session. I used a reflector camera right to bring some light back onto their faces.

SPECS > Canon EOS 5D Mark II using a 70–200mm at 102, f/3.5, $^1/_{500}$ second, and ISO 250.

Genuine Smiles ⬅

Then their personalities really started to shine. Big brother started playing peek-a-boo with little sister's face as she giggled through it. Genuine smiles continued. I used a reflector on camera right to bring some light onto their faces.

SPECS > Canon EOS 5D Mark II using a 70–200mm at 90, f/3.5, $^1/_{500}$ second, and ISO 250.

Warm Afternoon Light ⇧

After the two children were done sitting in the wagon and big brother went back to collecting sticks, I watched as she took the wagon into the field. The light was beautiful, as the warm afternoon light lit her from the front and she walked farther into the field. It was a nice way to end the session and to end the full series of images.

SPECS > Canon EOS 5D Mark II using a 70-200mm at 90, f/3.5, 1/500 second, and ISO 250.

A Simple Prop Helps Catch the Moment ⇗

This wagon prop is great when you need to keep multiple siblings in one place for a minute or two. I shoot fast, so that's all I need. After I get them smiling or looking my way, I ask them to kiss, hug, or snuggle into one another. I asked the sisters who were three and five years old to lean in and kiss their one-year-old brother. By shooting fast, I caught the moment.

SPECS > Canon EOS 5D Mark II using a 70-200mm at 90, f/3.5, 1/500 second, and ISO 250.

An Expression that Tells the Story ⇩

After the posed wagon portraits, I let them have fun with it. This meant giving sister a ride and it was loud so she held her ears closed while laughing along the ride. I focused on her in this image since she had the expression that was telling the story.

SPECS > Canon EOS 5D Mark II using a 70-200mm at 130, f/2.8, $^1/_{500}$ second, and ISO 250.

Best Smile and Eye Contact ⇖

Little brother even got a chance in the wagon as he sat in the back, and dad pulled him back and forth. In the distance, you can see his sisters walking in the unfocused background. This was the best smile and eye contact he gave me during this session. I am always thankful for my trusty red wagon.

SPECS > Canon EOS 5D Mark II using a 70-200mm at 95, f/2.8, $^1/_{500}$ second, and ISO 250.

Contained in One Place ⬆

These seventeen-month-old twins were all over the place. This is my favorite type of session, but of course, you need to get them both in one place for several minutes before you let them take off again. I sat them in the wagon and used my squeaky toy so they looked my way and smiled.

SPECS > Canon EOS 5D Mark II using a 70-200mm at 80, f/3.5, $\frac{1}{640}$ second, and ISO 250.

Color Harmony ⇒

Those beautiful twins whom I had photographed in the spring were twenty-two months when I photographed them for their fall session.

They remembered my wagon. This time they were big enough to give each other rides. I loved this moment as she pulled her twin brother in the wagon in front of the Wayside Inn Grist Mill. The color harmony worked great with the red wagon and red mill.

SPECS > Canon EOS 5D Mark II using a 70-200mm at 88, f/2.8 $\frac{1}{500}$ second, and ISO 320.

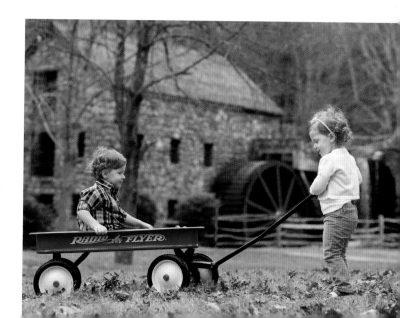

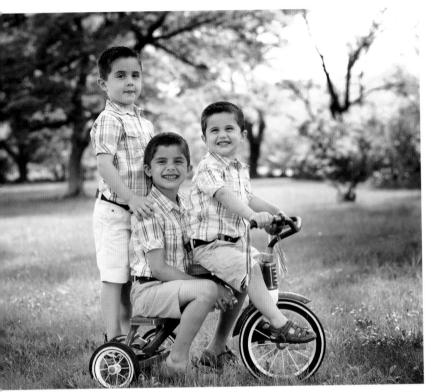

An Amazing Prop ⇐

The tricycle, that belonged to my oldest son, works great for sessions where you have children on the go. It works amazingly for posing too. The children can sit and stand safely on it. There's a little bell on there, too, that they love to ring and gets them smiling at themselves. This image was lit with the help of a reflector at camera right for fill.

SPECS > Canon EOS 5D Mark III, 70-200mm at 70, f/2.8, $^1/_{500}$ second, and ISO 320.

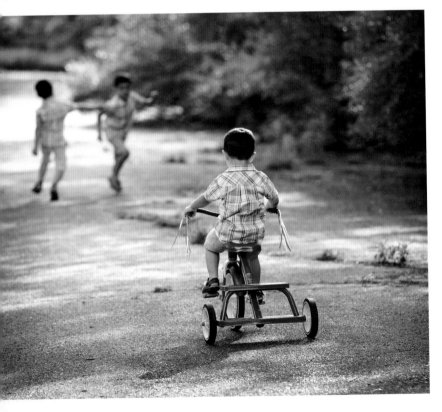

Let Them Have Fun ⇐

Then I let them go and have fun with the tricycle. Let them be boys. Telling the story of boyhood for just a few minutes during their session is so important to me and the families I photograph.

SPECS > Canon EOS 5D Mark II using a 70-200mm at 155, f/2.8, $^1/_{500}$ second, and ISO 320.

A Fun and
Easy Session ⇨

Then there's my red, antique-car replica that is child sized. Boys go crazy over it. They sit on the hood and pose like they are men with their first car. This boy loved it and was moving the lights and wheels as he looked back and smiled at me. This made the session fun and easy for both of us.

SPECS > Canon EOS 5D Mark II using a 135 lens, f/3.5, ¹/₅₀₀ second, and ISO 250.

Add a Filter to
Match the Scene ⬃

A one-year-old was dressed for this car without even knowing it. He wasn't mobile yet, so we sat him in front of it. I added a filter in processing to make it look like it was an aged image to match the feel of the scene.

SPECS > Canon EOS 5D Mark II using a 70-200mm at 110, f/4, ¹/₅₀₀ second, and ISO 250.

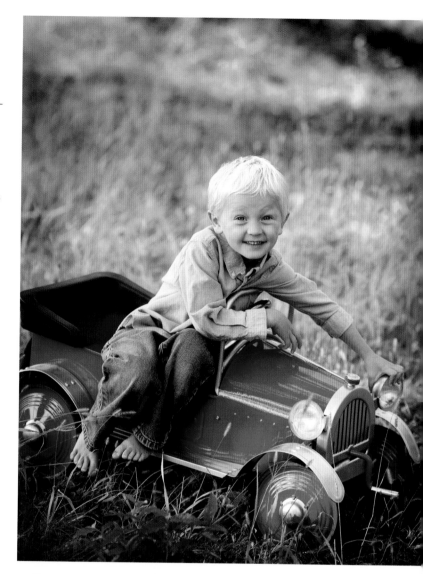

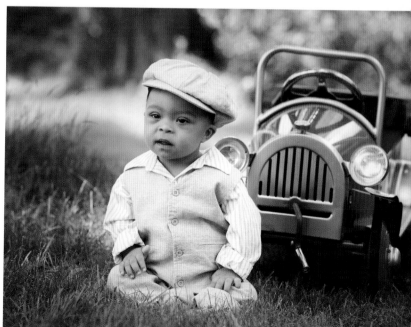

Multiple, Simple Props ⬇

I like to use multiple, simple props when there is just one child to photograph. This keeps them engaged during the session and they don't get bored or tired so quickly. I brought the newborn bed I use in my studio out to the local park for this nine-month-old's session. She laid in it and smiled right up at me.

SPECS > Canon EOS 5D Mark II using a 70–200mm at 160, f/4, $^1/_{500}$ second, and ISO 250.

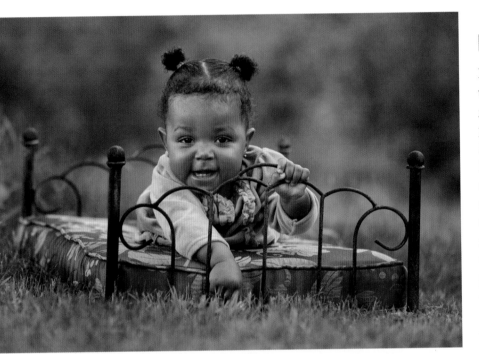

Entertained ⬆

I placed the bath-tub down in the grass and she was put in there with her diaper on. She looked over at me and smiled even more. It was a very warm late spring morning, and she was happy to be photographed throughout the session. The key was keeping her entertained with different things to sit or lay on.

SPECS > Canon EOS 5D Mark II using a 70–200mm at 115, f/4, $^1/_{640}$ second, and ISO 250.

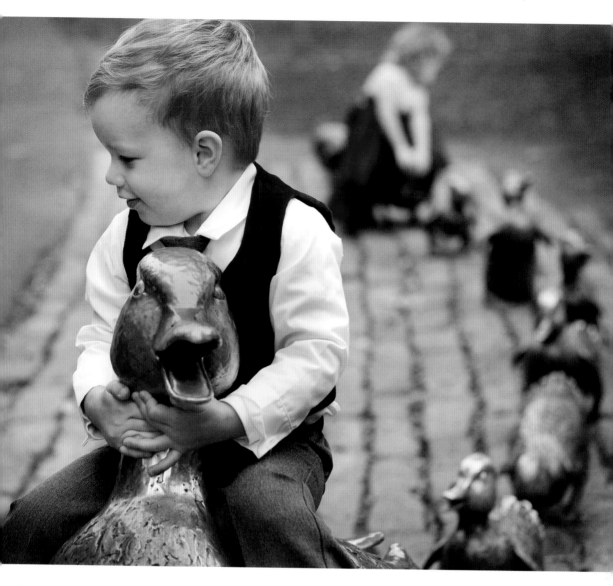

Position Quickly ⬆

I really like to use things that are at the location as a props. Steps, paths, and in this case, the *Make Ways for Ducklings* mini statues that children from all over the world (even adults) get the chance to sit on while visiting the Boston Public Gardens. We lucked out this particular fall morning, as this location was not filled with tourists and children visiting. These almost two-year-old twins hopped on them. I quickly got myself in position where I could see both children, while focusing on the child up front, and then using the line of ducks to lead to his twin sister.

SPECS > Canon EOS 5D Mark II using a 70-200mm at 70, f/4, ¹/₅₀₀ second, and ISO 250.

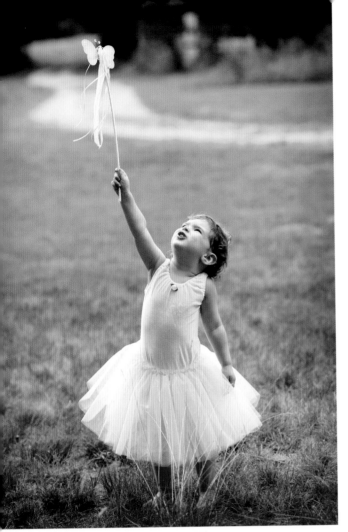

Children Will Do Things, Over and Over ⇐

This little girl came dressed in a tutu, along with her little sister, for their session. She had a magic wand and would place it in the air—as if she was making a wish. The light fell on her face beautifully, and she did this over and over again. Children usually will do things several times, so if you miss the exposure, you can be sure they will give you another chance.

SPECS > Canon EOS 5D Mark II using a 70-200mm at 115mm, f/3.2, $^1/_{500}$ second, and ISO 200.

Sunlight as a Backlight ⇗

Make a wish and it will come true. A favorite pasttime of kids this age is blowing dandelion seeds into the air and making a wish as they fly off into the sky. I love capturing these little moments when a child notices the field full of ready dandelion seed heads. I ask them to go gather a few and sit. Then I position myself so I can see the child blow and the seeds float away. Using the sunlight as a backlight is key because it illuminates the seeds flying up and coupled with the use of a wide aperture creates a soft focus background for the seeds to stand out against.

SPECS > Canon EOS 5D Mark II using a 70-200mm at 200mm, f/2.8, $^1/_{500}$ second, and ISO 200.

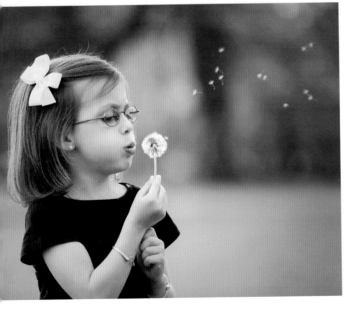

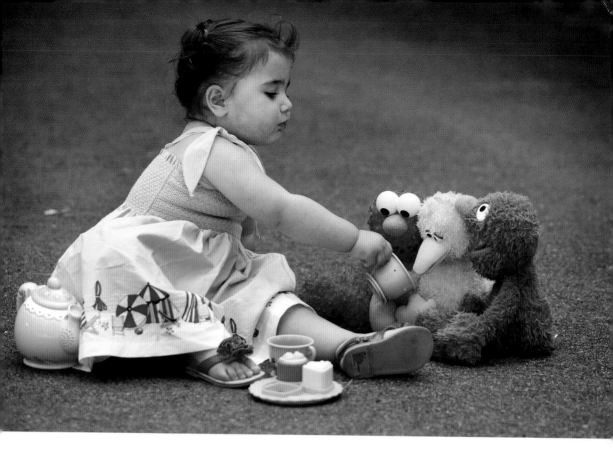

Tea for Four 🔼

Adorable tea for four with a two-year-old and her favorite stuffed animals. During this session at her home, she brought out all these little guys and set up right on her driveway. It was very cute and captured what her favorite things were at age two.

SPECS > Canon EOS 5D Mark II using a 70-200mm at 105mm, f/3.2, $\frac{1}{500}$ second, and ISO 320.

Not Feeling Stressed ⇒

She took time to pour tea for each of her friends during the little tea party on her driveway. She forgot I was there for a few minutes, which is a great break for children this age. They are having fun and not feeling stressed about having to smile and looking at the camera.

SPECS > Canon EOS 5D Mark II using a 70-200mm at 135mm, f/3.2, $\frac{1}{500}$ second, and ISO 320.

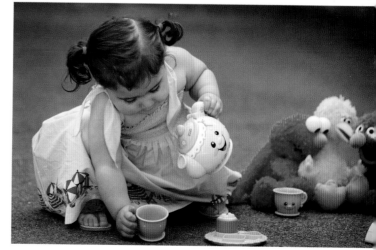

If They Don't Like the Grass ⇩

Sitting children on a suitcase or box helps to keep them in one place and off the ground, especially if they don't like grass. Some little kids just do not like to sit in the grass—it's itchy or they just haven't been in it yet. These two brothers sat down and smiled perfectly. One was only two-and-one-half years old, and the other was almost one year old when I photographed them in late summer when it was still warm out. They sat under nice tree cover with open sky in front of them for fill.

SPECS > Canon EOS 5D Mark II using a 135mm, f/3.5, 1/640 second, and ISO 250.

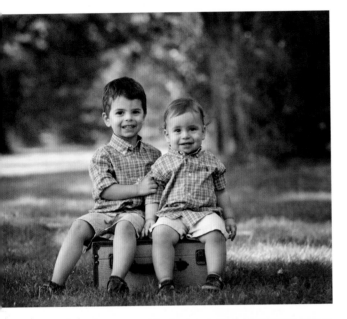

Keep Them in One Spot ⇗

This worked perfectly for the three-and-one-half-year-old and one-year-old siblings I photographed on this fall afternoon. They were comfortable with me after we did their family portraits and were happy to stay in one spot for a few moments. The light was beautiful and I filled it with a reflector camera right.

SPECS > Canon EOS 5D Mark II using a 70–200mm at 105mm, f/3.2, 1/500 second, and ISO 500.

Sitting Babies in a Crate ⇒

Sitting babies in a crate to keep them propped is great for outdoor sessions. This six-month-old wasn't able to sit up unassisted yet. He was nice and warm in his sweater, winter hat and mittens, and we covered him in a blanket with a few leaves to keep that fall look, which was happening naturally in the background. He just looked up at his mom and smiled.

SPECS > Canon EOS 5D Mark II using a 85mm lens, f/2.5, 1/1000 second, and ISO 400.

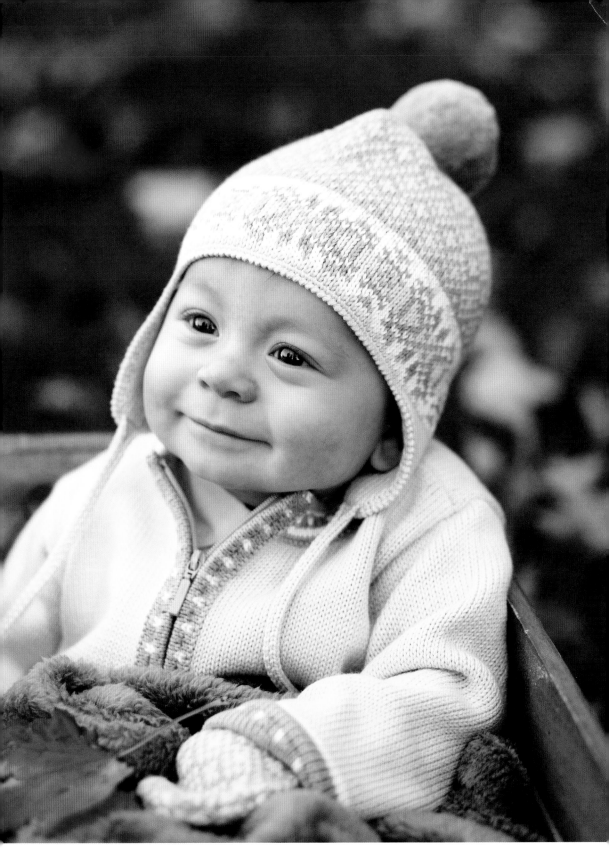

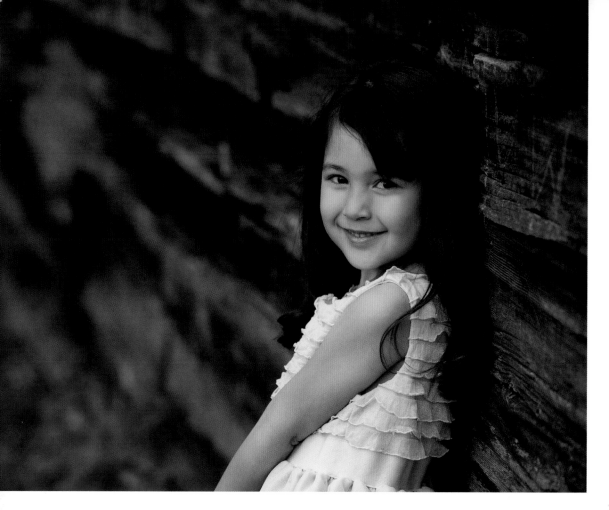

Leading Lines ⇧

I love posing children using some type of leading lines. This little girl leaned up against an old barn and smiled my way beauti-fully. She was in the shade, but I have a nice open sky in front of her to bring the light into her eyes.

SPECS > Canon EOS 5D Mark II using a 70-200mm at 130mm, f/3.5, $1/_{500}$ second, and ISO 250.

Warmer Colors and Light ⇦

The same barn was used in this image, but it was a few months later, in the late fall. The colors and the light were warmer from the fall foliage around the trees. I still used the open sky to capture the light in his eyes.

SPECS > Canon EOS 5D Mark II using a 70-200mm at 168mm, f/3.5, $1/_{500}$ second, and ISO 320.

Sunlit Face ⇧

While sitting on a tree stump during his family session, this five-year-old little guy looked up at me and the sun lit his face perfectly. as it was filtered through the weeping willow branches. Trees make great natural light diffusers.

SPECS > Canon EOS 5D Mark II using a 70-200mm at 100mm, f/3.5, 1/500 second, and ISO 400.

Open Sky ⇨

Sitting and looking up at mom and dad. She gave the biggest smile as her eyes sparkled.

The open sky provided fill while she was in the open shade.

SPECS > Canon EOS 5D Mark II using a 70-200mm at 135mm, f/3.5, 1/500 second, and ISO 400.

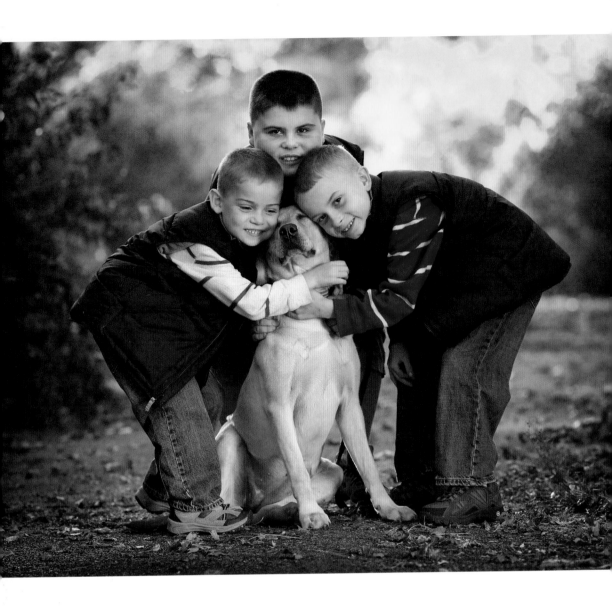

Siblings and Their Pets ⬆

Pets are such a huge part of families. In most cases, they are the parents' first child before the first human child arrived. I include them whenever possible for family and children sessions. Three boys with their sister dog who was five months old at the time. She leaned back into them as they hugged her. It was a late fall afternoon, so I used a reflector to bounce some light back onto them.

SPECS > Canon EOS 5D Mark II using a 135mm, f/3.5, $1/_{500}$ second, and ISO 400.

Pets Posing
According to Species ⇒

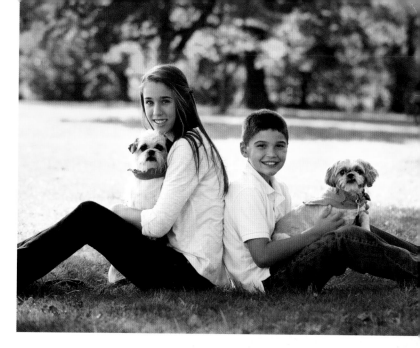

Pet behavior and poses are often characteristic of their species, breed, and age. This brother and sister brought their dogs for their outdoor session and they sat on their laps and posed. I had mom call their names as I began taking their portraits. I used a reflector for fill coming in on camera right.

SPECS > Canon EOS 5D Mark II using a 70-200mm at 102mm, f/3.5, ¹/₅₀₀ second, and ISO 320.

Cats ⇒

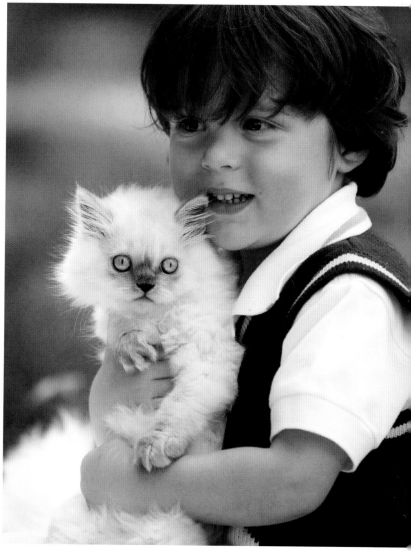

Cats can be hard. They scare easily and run off quicker than a two-year-old child will. Here is a two-and-one-half year-old holding his kitten in his home yard. Her eyes were amazing, though she only looked at me for a few frames. It was all I needed to capture this beautiful portrait.

SPECS > Canon EOS 5D Mark II using a 70-200mm at 170mm, f/3.5, ¹/₅₀₀ second, and ISO 320.

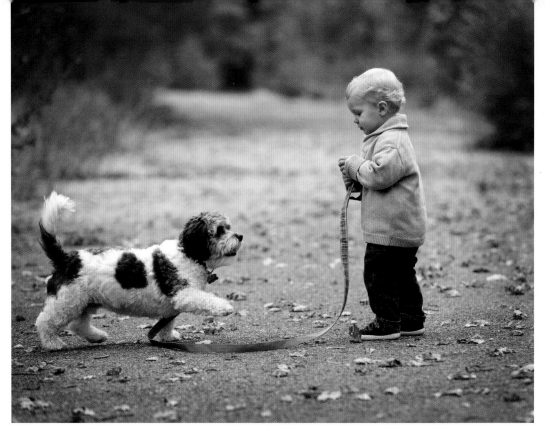

A Series from a Family Session ⇧

This was a fun family session. I had photographed these two when the little boy was a newborn. At this session he was eighteen months old, and he wanted to show me how he could walk his dog. First, making sure that it was okay with his parents, dad then gave him the leash.

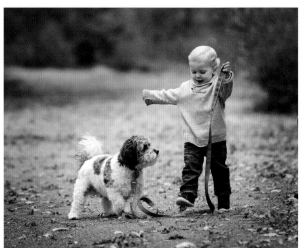

SPECS > Canon EOS 5D Mark II using a 70–200mm at 165mm, f/3.5, ¹⁄₅₀₀ second, and ISO 250.

Using Available Light ⇗

So off they went on their little walk on the path inside the park. Adorable moments emerged as they walked one another. I shot using available light coming in from the open sky at the front of the path and I shot fast, zooming in a bit more.

SPECS > Canon EOS 5D Mark II using a 70–200mm at 200mm, f/3.5, ¹⁄₅₀₀ second, and ISO 250.

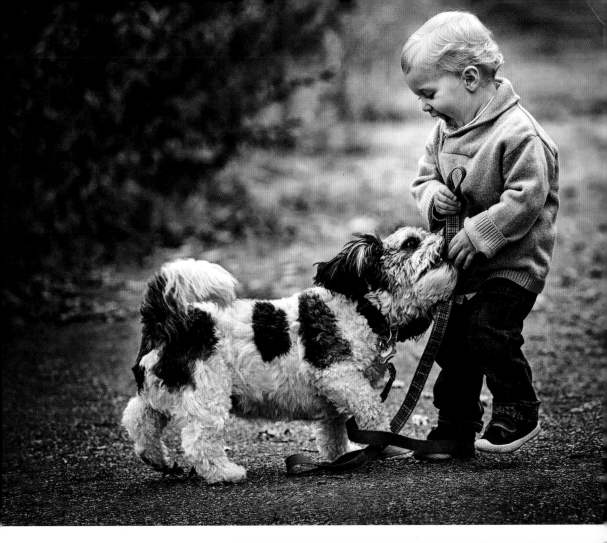

Who's Walking Who? ⇧ ⇨

The best moment was when this little doggy decided it was his turn to walk his little brother. I even thought the colors were amazing for this fall day. I made this image black & white and entered it into competition, titled "Who's Walking Who?" It won a Kodak Gallery Award at PPAM and served as a work in the IPC Loan Collection in 2013.

SPECS > Canon EOS 5D Mark II using a 70-200mm at 155mm, f/3.5, $\frac{1}{500}$ second, and ISO 250.

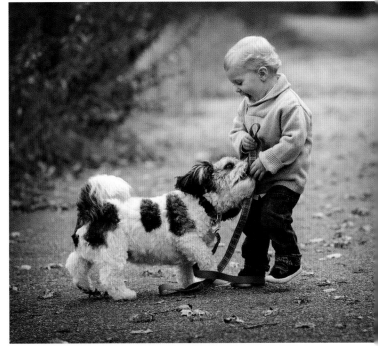

Show Natural, Late-Afternoon Light ⇩

When I had the opportunity to photograph a seven-year-old and his dog in the backyard, I knew it would be fun, but the situation turned around when the boy hopped into the dog's outdoor tub, and the dog came over to give him a kiss as if to say, "Hey, this is my bath time—not your!"

The images shows natural, late-afternoon light; then it was turned into a black & white image to have a timeless feel. Another competition image that merited at the PPAM and IPC General collection.

SPECS > Canon EOS 5D Mark II using a 70-200mm at 120mm, f/3.5, $^1/_{500}$ second, and ISO 320.

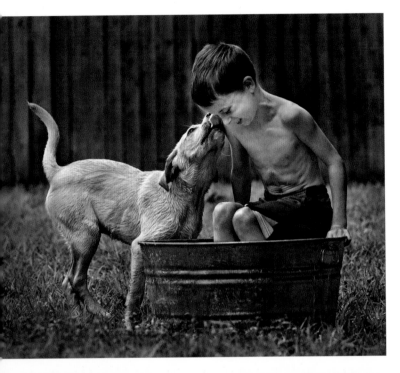

Matching Sweaters ⬈

A dog in a sweater that matches his older human siblings—it's perfectly normal and fun. I photographed these three in their backyard on a warm, late-fall afternoon. Using available light, I photographed them in between bouts of running around. I find dogs will get tired and snuggle into their little owners' arms after a few quick runs. He tired out, and his brother and sister came in for the hug to make this amazing portrait.

SPECS > Canon EOS 5D Mark II using a 70-200mm at 200mm, f/3.5, $^1/_{500}$ second, and ISO 500.

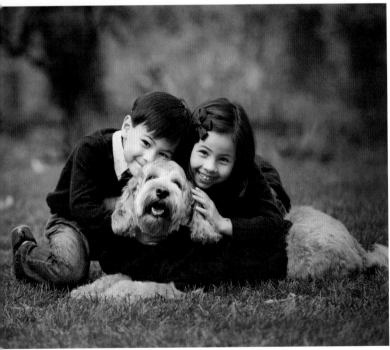

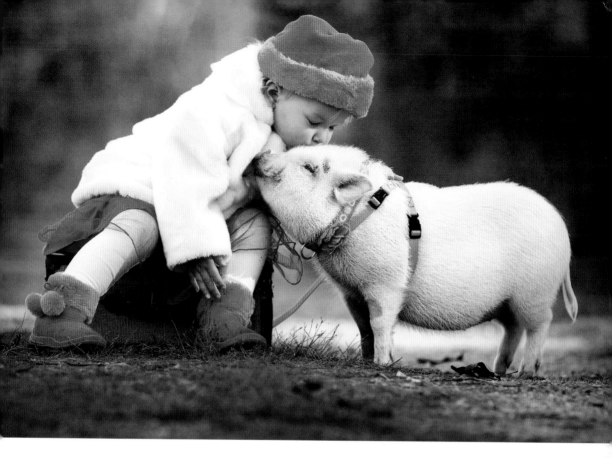

Matching Colors ⇧

Who doesn't love a little girl and her grand-ma's pet pig? A three-year-old little girl and a four-month-old pig dressed in matching colors. I had no idea what to aspect when I started the session. Grandma walked the pig up to her granddaughter, on one of my suitcases. Then the little girl leaned over and gave the pig a kiss!

SPECS > Canon EOS 5D Mark III using a 70–200mm at 165mm, f/3.5, ¹/₅₀₀ second, and ISO 400.

A Great Memory Captured ⇒

After that sweet little kiss, we let her take Ruby, the pig, for a walk on the path. Ruby was a fast walker and the pink leash flew behind them as the little girl tried to keep up. So much fun—and what a great memory captured in these images.

SPECS > Canon EOS 5D Mark II using a 70–200mm at 170mm, f/3.5, ¹/₅₀₀ second, and ISO 400.

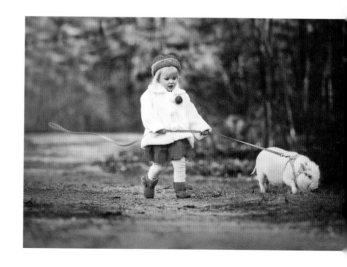

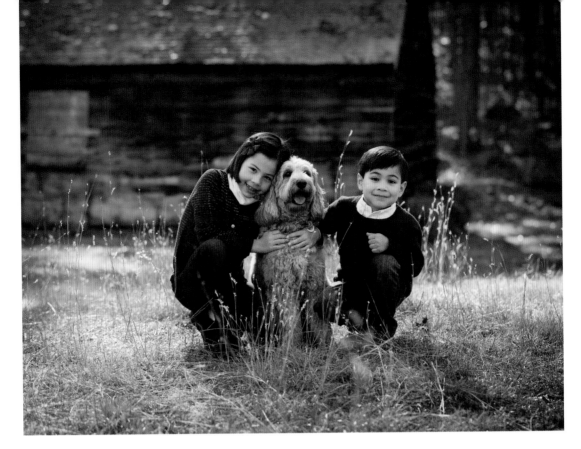

Amazing Personalities ⇧

Dogs have amazing personalities. They can sit with their siblings and even smile. This three-year-old labradoodle did just that on a late fall morning. His attention span was short lived though. The light was beautiful as it came over from behind them, and I used a reflector, camera right, to bring in a little fill on them.

SPECS > Canon EOS 5D Mark II using a 70–200mm at 88mm, f/3.5, $^{1}/_{500}$ second, and ISO 400.

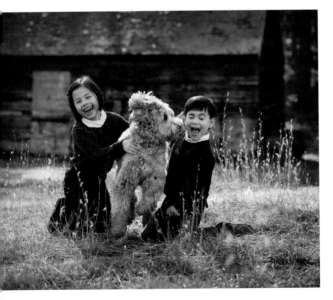

Priceless Expressions ⇦

Just like that—I call it a squirrel moment—he took off out of the frame. The kids expressions were priceless as he took off. I kept shooting to capture whatever was about to happen, like I was at a football game photographing a running back with the ball.

SPECS > Canon EOS 5D Mark II using a 70–200mm at 88mm, f/3.5, $^{1}/_{500}$ second, and ISO 400.

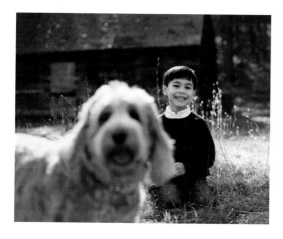

An Out-of-Focus Subject Can Work ⇧

I decided to switch gears and focus on the individual kids. Well, look who decided he wanted his own portrait and photobombed his brother. I love this image. Yes, he's not in focus, as I was focusing on his brother, but you can still see his expression. Yes, the dog is laughing at me.

SPECS > Canon EOS 5D Mark II using a 70–200mm at 70mm, f/3.5, 1/500 second, and ISO 400.

Follow the Subject, Change Focus ⇩

You bet this young, four-legged friend knew what he was up to. I give my word—he was laughing at me as I moved my focus to him. He ran toward me, while his siblings reached out their arms as if to bring him back. Although my focus changed, my camera settings stayed the same. I zoomed in just a bit on him.

SPECS > Canon EOS 5D Mark II using a 70–200mm at 105mm, f/3.5, 1/500 second, and ISO 400.

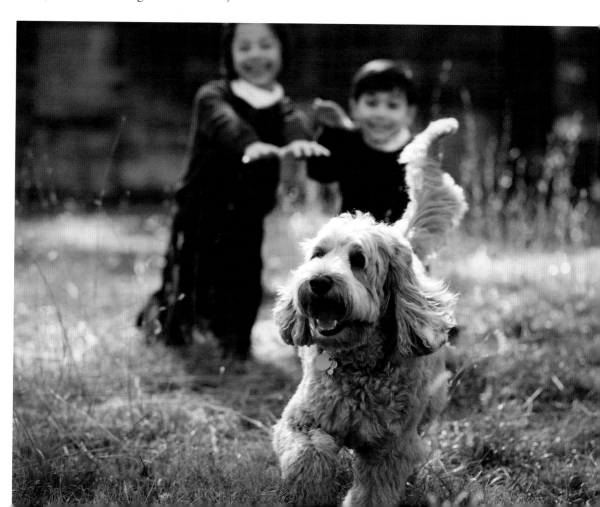

I shot fast not knowing

what to expect next . . .

Keep Shooting 📷

Photographing three sisters on a stone path in a garden area, I have them sit down on the path when all of a sudden a little frog jumps in front of them. The older sister puts her hands up and reacts to it immediately. I shot fast not knowing what to expect next, but I knew to just keep on shooting. Their parents were close by and I knew if they got to be fearful they could save them from the frog.

SPECS > Canon EOS 5D Mark II using a 70–200mm at 85mm, f/3.5, $1/500$ second, and ISO 250.

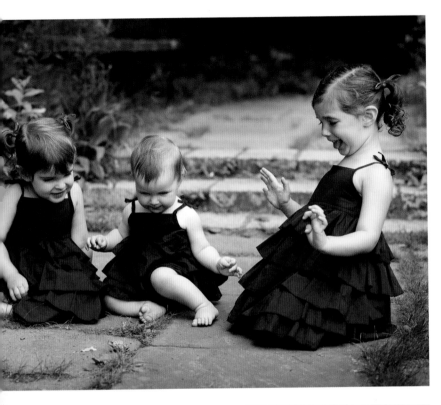

Catch Those Details 📷

The next thing I knew, the big sister, who was the most fearful at first, was trying to catch that little frog. I love shooting with the 70–200 zoom lens. It's moments like these where I don't have to move to disturb what is going on. I can stay put and get in closer by using the zoom to catch those wonderful details.

SPECS > Canon EOS 5D Mark II using a 70–200mm at 115mm, f/3.5, $1/500$ second, and ISO 250.

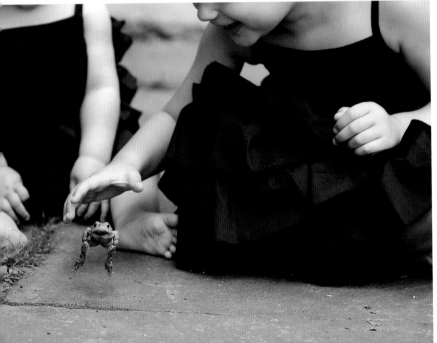

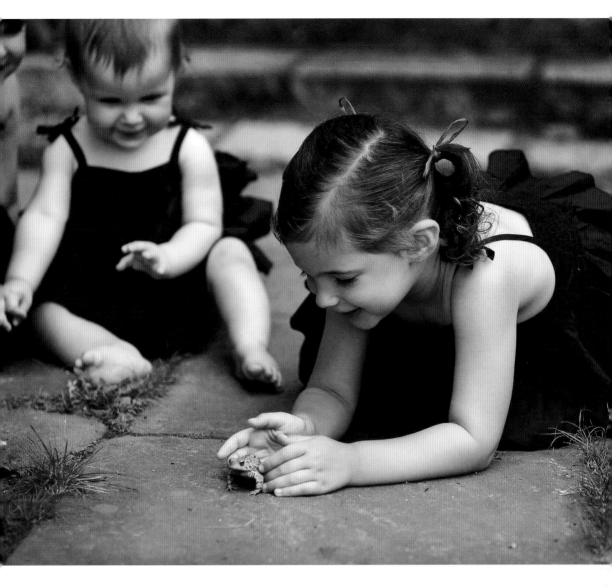

Shoot, Shoot, and Shoot ⇧

Then she leans in for the catch as her two younger sisters watch anxiously. This was shot with available light using my skills as a photojournalist. Sit back and do not disturb what I'm seeing, but shoot, shoot, and shoot.

This image merited at PPAM and was a General Collection image at IPC It was submitted as a black & white image.

SPECS > Canon EOS 5D Mark II using a 70–200mm at 130mm, f/3.5, $\frac{1}{500}$ second, and ISO 250.

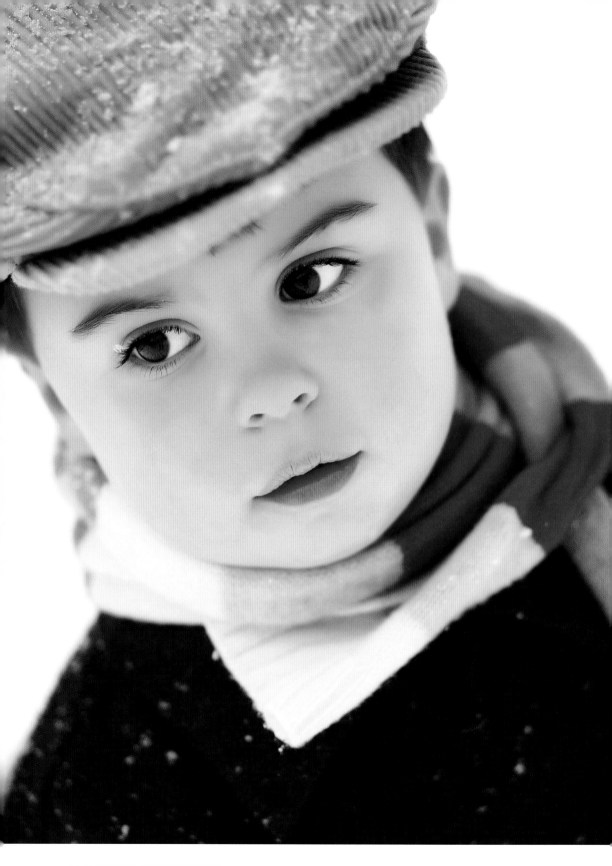

A Beautiful Portrait ⇐

Living in Massachusetts, we have long snowy winters. I try to take advantage of the freshly fallen snow whenever I can. This four-year-old was photographed as the snow lightly fell, and as a flake landed on his eyelashes, he looked at of the corner of his eyes to see it. This made for a beautiful portrait without having him look at the camera.

SPECS > Canon EOS 5D Mark II using a 85mm lens, f/1.8, ¹/₁₀₀₀ second, and ISO 250.

Shoot Fast ⇒

Like throwing leaves in the air, snow is just as fun, and the expressions are worth it. Shoot fast, and try not to get hit yourself.

SPECS > Canon EOS 5D Mark II using a 85mm lens, f/1.8, ¹/₁₀₀₀ second, and ISO 250.

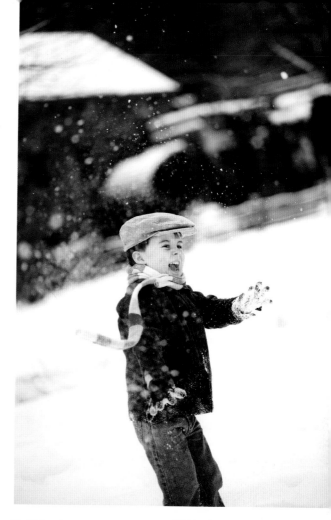

Running and Walking Away ⇒

Love those running and walking away images. This time I photographed the footsteps he left in the snow as he ran off. This adds a nice storytelling feature to session images as an ending scene. In these images, I made myself work for what I captured. I only took out one camera body with an 85mm prime lens. So I had to move to and from my subject rather just zoom in and out. It makes me be more creative when I do this every so often.

SPECS > Canon EOS 5D Mark II using a 85mm lens, f/1.8, ¹/₁₀₀₀ second, and ISO 400.

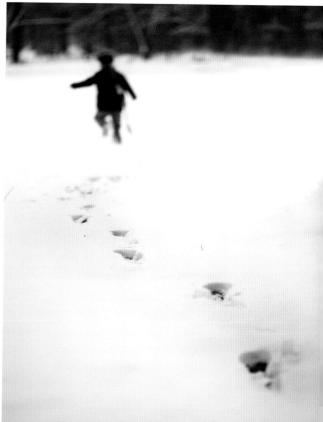

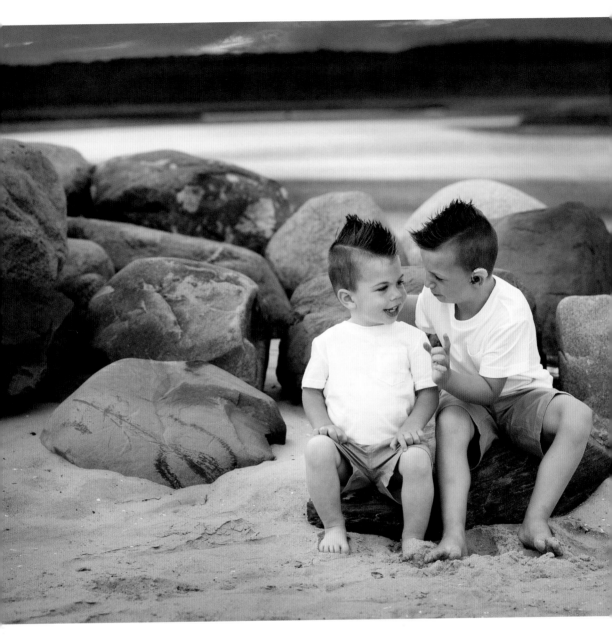

Document the Moments ⌂

The beach and bad weather can be a bad combination. The sun was setting, and we knew some rain was coming in shortly. I had to shoot quickly and document the moments between two brothers who were five and two years old. As they sat on the rocks, the older brother started explaining to his little brother that he needed to look at me and smile. But what he was doing, was what I wanted a moment between two brothers happening was right in front of my camera.

SPECS > Canon EOS 5D Mark III using a 70–200mm at 70mm, f/3.5, $^{1}/_{500}$ second, and ISO 250.

Just Out of the Frame ⇩

Then those two little guys took a walk toward the water. The sun was setting as the rain came in. Mom and dad were close by, just out of frame, for safety and because the two-year-old didn't want to leave their sides.

SPECS > Canon EOS 5D Mark III using a 70–200mm at 70mm, f/3.5, $^1/_{500}$ second, and ISO 250.

Mom and dad were close by, just out of the frame not only for safety, but . . .

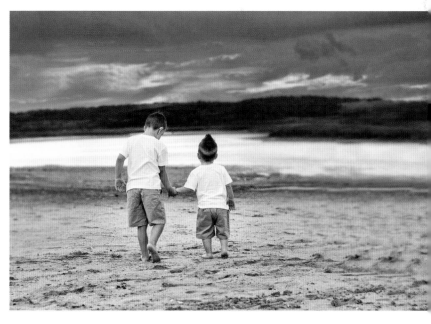

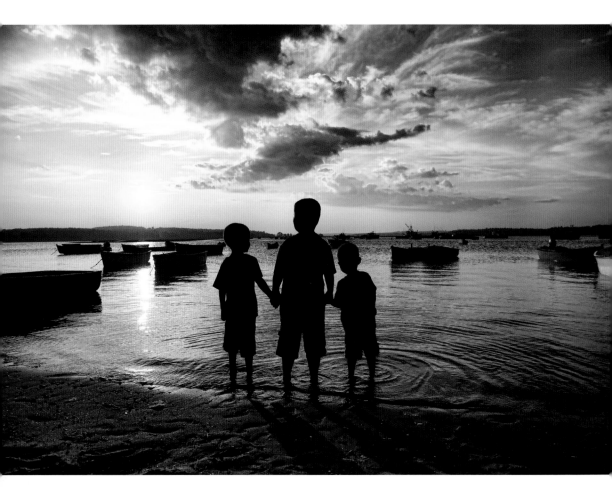

Create a Silhouette ⬆

Sometimes you are trying to create a beautiful portrait of three siblings, but they feel they are finished with the session. Well, turn them away from the camera and create a silhouette. This worked perfectly for these three brothers who were six, three-and-one-half, and two-years-old. The two-year-old was so done with the photo session—but then we saw this gorgeous sunset we couldn't pass it up. No one knows what expressions are on their faces when they are turned away from the camera.

This is a unique East Coast location where typically sunsets are not over the water. Here a river feeds into the estuary from the east and the sun sets over the water on the inlet.

SPECS > Canon EOS 5D Mark II using a 24-70mm at 24mm, f/7.1, $^1/_{1000}$ second, and ISO 250.

. . . turn them away from the camera and create a silhouette.

A Wide-Angle Lens
for Sense of Location ⇩

Wide-angle lenses are really recommended for silhouettes like these.

We let them discover and climb on the nearby rocks. I kept them in silhouette as they climbed. The sky was amazing. They were pretty much finished with paying attention to me, so I kept play on the rocks for another silhouette. Wide-angle lenses are really recommended for silhouettes like these, as they allow you to really create a feel of the location.

SPECS > Canon EOS 5D Mark II using a 24–70mm at 24mm, f/7.1, $^1/_{1000}$ second, and ISO 250.

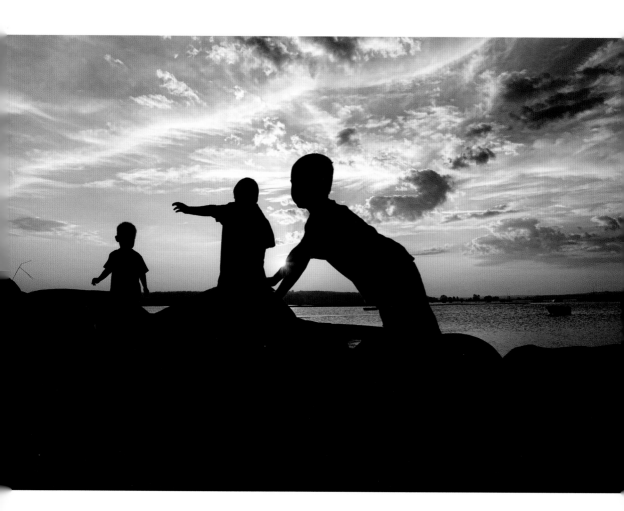

Silhouettes, a Favorite Ending ⬇

Silhouettes are really my favorite endings to a family beach session. For this session, I used my 70–200mm so I could get far away, but down low from them. They are actually up in a dune area and I'm laying down looking up from the sand. Mom and dad lifted their children up into the air a few times, so I could capture this beautiful portrait for them.

SPECS > Canon EOS 5D Mark II using a 70-200 2.8 II IS at 85mm, f/11, $^1/_{640}$ second, and ISO 200.

Recreate a Silhouette ⬇

Almost exactly two years later, I photographed this same family, who now has a third child. It was wonderful to recreate this silhouette for them with her in it. The skies were incredible on both of these evenings.

SPECS > Canon EOS 5D Mark III using a 70-200 2.8 II IS at 70mm, f/8, $^1/_{500}$ second, and ISO 400.

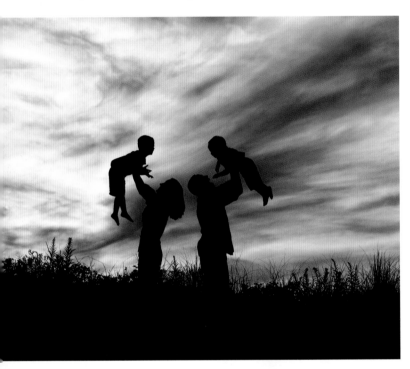

Time for Adjustments ⇨

Father and son toward the end of a session. Dad lifts him in the air, and I quickly make adjustments in-camera to create a silhouette. Dad lifted him up a few times, so there was ample time for me to capture them framed like this.

SPECS > Canon EOS 5D, 70-200mm 2.8 I IS at 105mm, f/11, $^1/_{1250}$ second, and ISO 400.

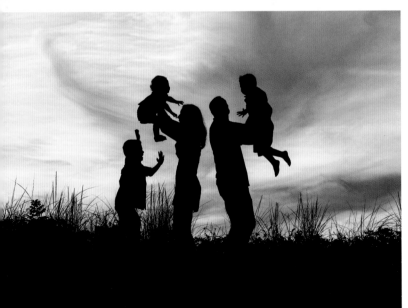

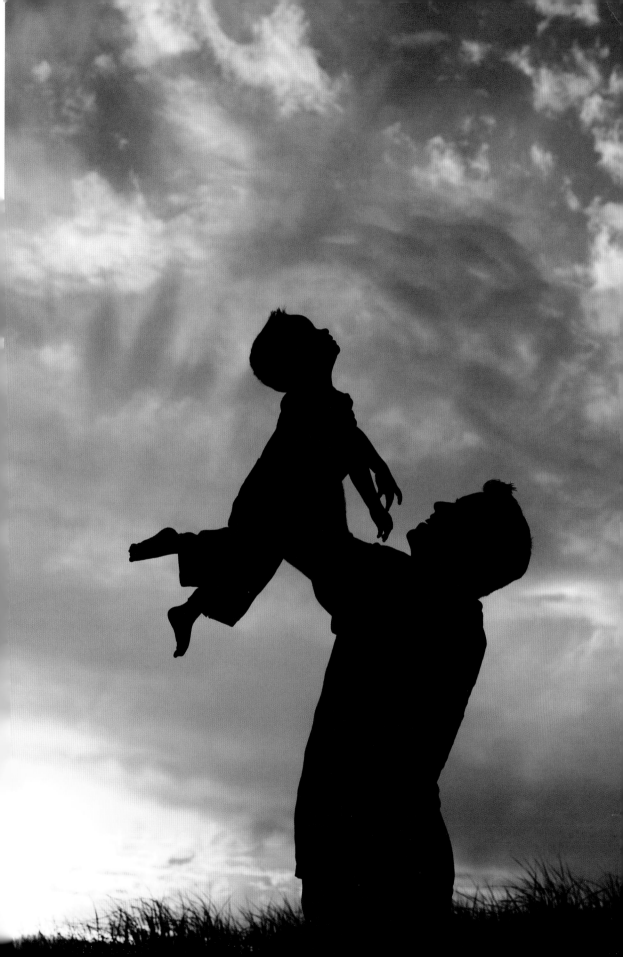

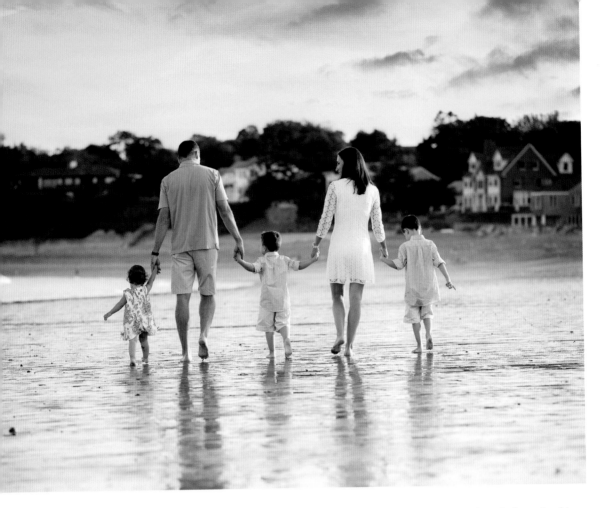

A Welcome Change ⇧

Beach sessions are a welcome change after our long winters. I am fortunate to live within driving distance of beautiful beaches in New England. This family with three children was photographed as they walked along the beach. The sun was beginning to set to their right as they made their way along the beach. This walk is a nice break from looking at the camera for children and their parents.

SPECS > Canon EOS 5D Mark III, 70–200 2.8 II IS 2.8 I IS at 145mm, f/4, ¹⁄₆₄₀ second, and ISO 250.

Time to Warm Up ⇦

I loved how this eighteen-month-old little girl came up to me and looked right at my camera, as her brothers played on the beach in the background. It took some time for her to warm up to me, and this was the initial access image she gave me.

SPECS > Canon EOS 5D Mark III, 70–200 2.8 II IS 2.8 I IS at 145mm, f/4, ¹⁄₆₄₀ second, and ISO 250.

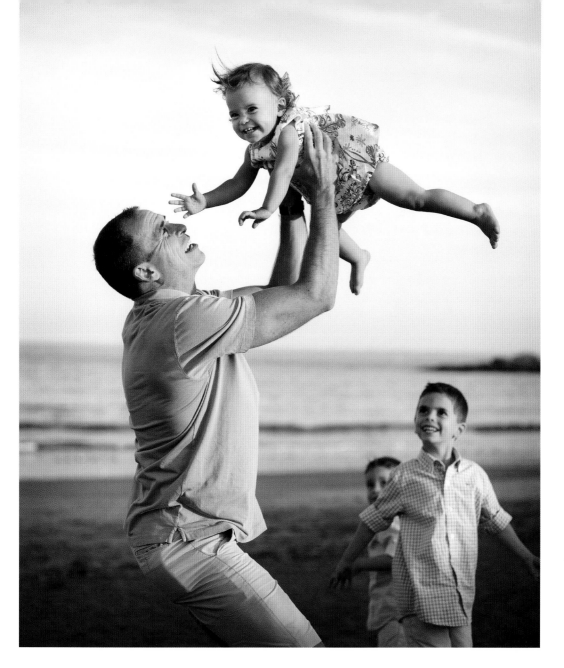

Start Two Hours Before Sunset ⇧

There's something about the beach—no matter the time of day—as everyone has fun. This session started about two hours before sunset in order to take advantaged of the lower sun angle and the absence of crowds. This dad would raise each of his children up in the air, one by one. This was my favorite image of the bunch.

SPECS > Canon EOS 5D Mark III, 70-200 2.8 II IS 2.8 I IS at 70mm, f/2.8, $^1/_{2000}$ second, and ISO 250.

Following Them Up the Path ⇩

After I photographed them running back and forth from their parents, I followed the children as they walked up the path toward the beach. I had mom and dad right behind me as I did this.

SPECS > Canon EOS 5D, 70–200 at 73mm, f/3.5, $\frac{1}{640}$ second, and ISO 200.

A Storytelling Element ⇧

Using layered images are great. It offers a storytelling element as the children ran from their parents laughing toward me at the start of their session.

SPECS > Canon EOS 5D, 70–200 at 85mm, f/3.5, $\frac{1}{500}$ second, and ISO 200.

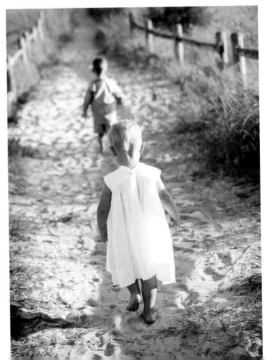

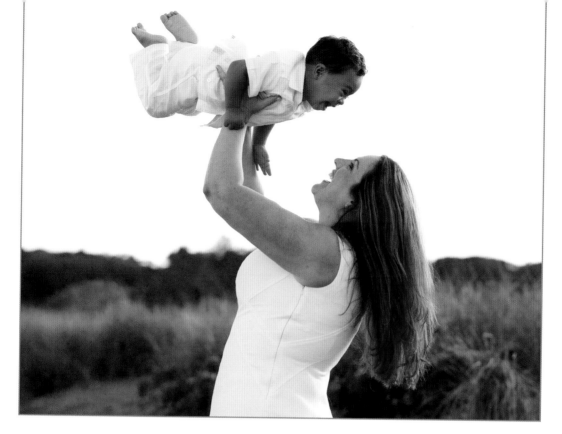

Go-to Action Poses ⇧

Lifting the child into the air is one of my go-to action poses. It helps get the child and parent into the session mood. I wanted them to realize this isn't going to be one of those sit-for-an-hour sessions, where they smile at the camera the whole time. It's going to be a fun and do what you want and show me genuine smiles.

SPECS > Canon EOS 5D Mark II, 70–200 at 95mm, f/3.5, $\frac{1}{500}$ second, and ISO 250.

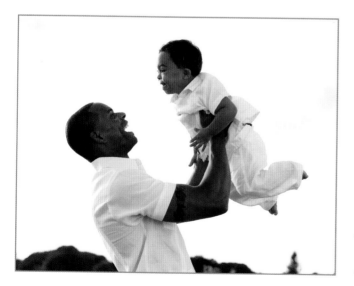

In Action with Their Child ⇦

I always strive to get both parents in action with their child whenever possible. This little guy, who was two years old, laughed and smiled as he was lifted into the air by both parents. I love how the parents mimicked his big smile too.

SPECS > Canon EOS 5D Mark II, 70–200 at 70mm, f/4, $\frac{1}{500}$ second, and ISO 200.

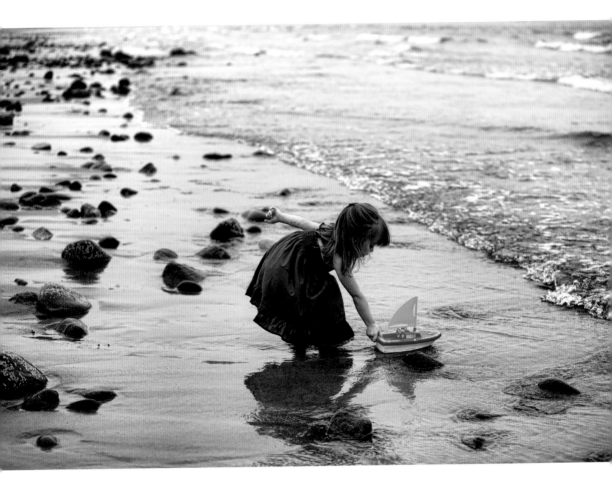

Moments of a Child's Discovery ⇧

Those quiet little moments of a child discovering what the beach has to offer, can be beautiful. I like to bring a little boat, starfish, or big shell to my beach sessions. These props let the child have fun with something they might not normally have. This little girl took the boat and tried to set sail along a rocky shoreline. I loved how her arm would swing back with every launch. Dad was close by so she wouldn't go too far or lose her boat.

SPECS > Canon EOS 5D Mark II, 70–200 at 105mm, f/3.5, $^{1}/_{1000}$ second, and ISO 125.

These props let the child have fun with something they might not normally have.

Documenting Family Moments ⇓

Standing back and documenting family moments during the session can create such beautiful portraits. I love how dad has an arm around mom who is holding baby, and their older daughter is just running back and forth along the shore.

SPECS > Canon EOS 5D Mark II, 70–200 at 24mm, f/3.5, $\frac{1}{500}$ second, and ISO 320.

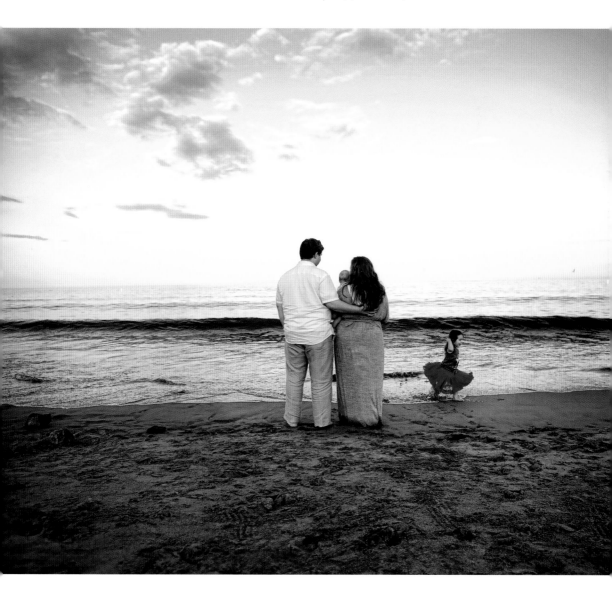

Keepsakes of Mommy-and-Me ⇩

Mommy-and-me moments happen at almost every session. I really strive to capture beautiful images with mom and her child, so she has them as a keepsakes. This mom and her six-month-old are sitting at the base of a tree.

Mom reached out to give her daughter a flower she had brought along for their session. The baby girl looked right at the flower as mom's expression peaked with a smile.

SPECS > Canon EOS 5D Mark II, 70–200 at 155mm, f/4, $^1/_{500}$ second, and ISO 250.

Looking at the Same Time ⇧

This little baby was so happy as mom lifted her up in the air. I loved how she looked right at my camera at the same time mom did.

SPECS > Canon EOS 5D Mark II, 70–200 at 165mm, f/4, ¹/₅₀₀ second, and ISO 250.

A Special Moment Captured ⇩

This six-year-old little boy ran up and gave his mom the biggest hug toward the end of our session. It was a special moment and I was so happy to be there to capture it.

SPECS > Canon EOS 5D Mark III, 70–200 at 200mm, f/3.5, $\frac{1}{500}$ second, and ISO 400.

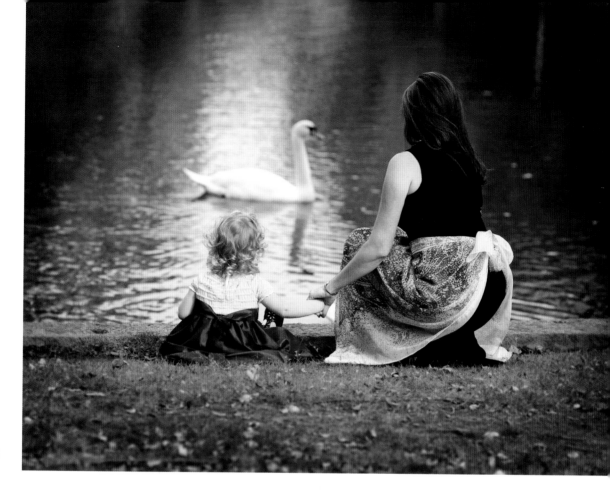

Ready for the Swan ⇧

Mom and her almost-two-year-old daughter sat and watched as one of the swans at the Boston Public Gardens swam by. The little girl had been inching toward the water. So mom grabbed her hand, and they sat and waited for the swan. I was ready for it to come by as I sat behind them.

SPECS > Canon EOS 5D Mark II, 70–200 at 135mm, f/3.5, $\frac{1}{1000}$ second, and ISO 250.

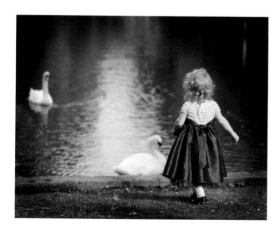

Picturesque Background ⇐

This was the previous moment I captured before mom came over to hold her daughter and watch the swans at the Boston Public Gardens. Both are beautiful moments with a picturesque background.

SPECS > Canon EOS 5D Mark II, 70–200 at 135mm, f/3.5, $\frac{1}{800}$ second, and ISO 250.

A Nice Snuggle Moment ⇧

Mom was trying to get her son to smile and look at her when he turned and looked my way. A nice moment as mom snuggled closer to him.

SPECS > Canon EOS 5D Mark III, 70-200 at 95mm, f/3.5, $^1/_{800}$ second, and ISO 250.

A Kiss on the Cheek ⇒

This little guy came up and hugged his mom, and just as I started taking photographs of them, he gave her a kiss on the cheek. Mom's smile got even larger, and it was such a great moment.

SPECS > Canon EOS 5D Mark II, 70-200 at 145mm, f/3.5, $\frac{1}{500}$ second, and ISO 160.

A Moment to Remember ⇘

The moment when this session was over, the child closed her eyes, and rested her head on her mom's shoulder. I love to capture that moment for mom to see and remember forever.

Shot at the end of a beach session as we were walking back up to their house.

SPECS > Canon EOS 5D, 85mm, f/3.5, $\frac{1}{500}$ second, and ISO 400.

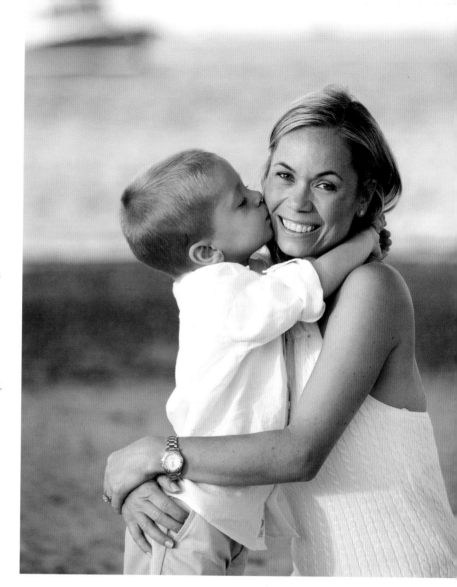

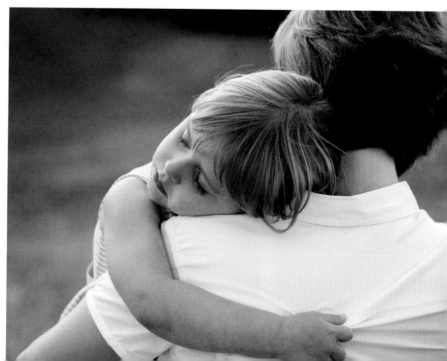

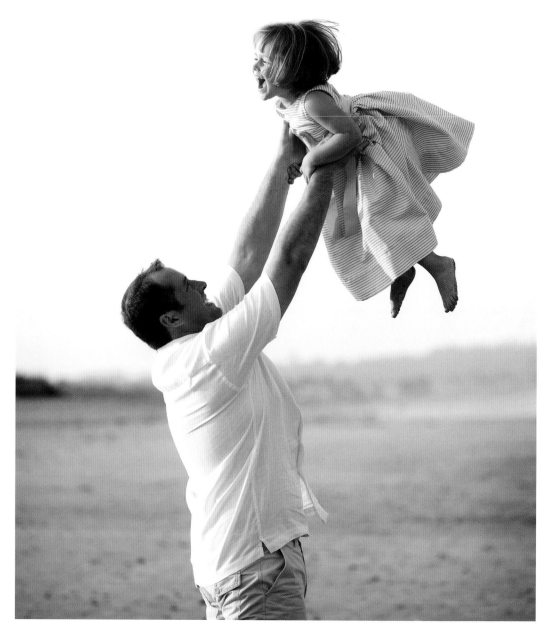

The Setting Sun Lights a Face ⇧

The little girl on the previous page, who rested her head on her mom's shoulder, was tired out by her dad flying her through the air on the beach. The sun was setting off to the left, and it lit her face beautifully as she was lifted into the air.

SPECS > Canon EOS 5D Mark III, 70–200 at 150mm, f/4, $^1/_{500}$ second, and ISO 200.

The Look ⇩

This four-year-old, who was on the go, need-ed a little daddy time, so dad put him on his shoulders. As dad did this, he held his arms as they looked right at each other smiling.

SPECS > Canon EOS 5D Mark II, 70–200 at 95mm, f/3.5, $\frac{1}{500}$ second, and ISO 250.

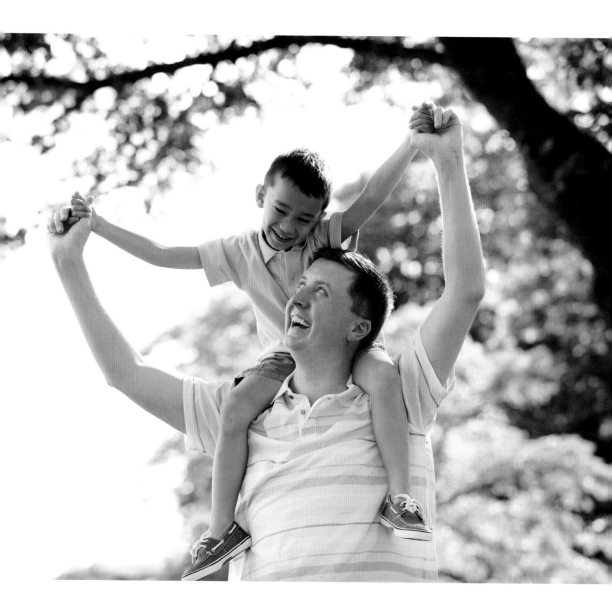

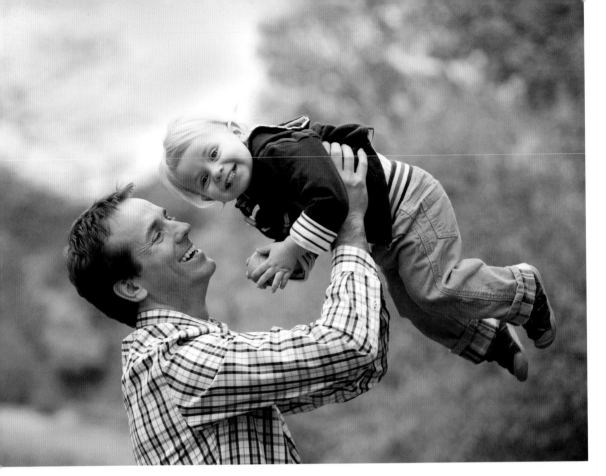

A Great Trick ⇧

Dad lifts his eighteen-month-old son into the air to get him to smile a little more for photos. This is a great trick to keep those children who might be done or need a little warming up.

SPECS > Canon EOS 5D Mark II, 70–200 at 140mm, f/4, $\frac{1}{500}$ second, and ISO 250.

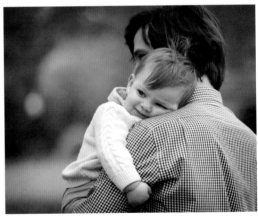

Time in-between Moments ⇲

This is the time in between moments when his eighteen-month-old son needed a little snuggle. He held onto the back of dad's arm, as he looked over his own shoulder toward mom, who was just out of the frame.

SPECS > Canon EOS 5D Mark III, 70–200 at 180mm, f/3.5, $\frac{1}{800}$ second, and ISO 250.

So Expressive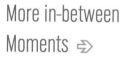

Dad was reading a story to his daughter during their at-home session in their yard. The dog came up and sat right by them, too. The little girl was so expressive as dad read to her.

SPECS > Canon EOS 5D Mark II, 70–200 at 70mm, f/3.2, $\frac{1}{500}$ second, and ISO 320.

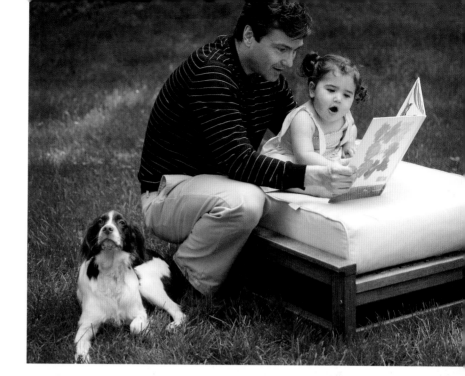

More in-between Moments ⇒

A nearly-two-year-old little boy gave his dad a hug during those in-between moments at their family session in Boston. Always keep shooting, even during what may seem to be downtime during a session.

SPECS > Canon EOS 5D Mark II, 70–200 at 135mm, f/3.5, $\frac{1}{640}$ second, and ISO 250.

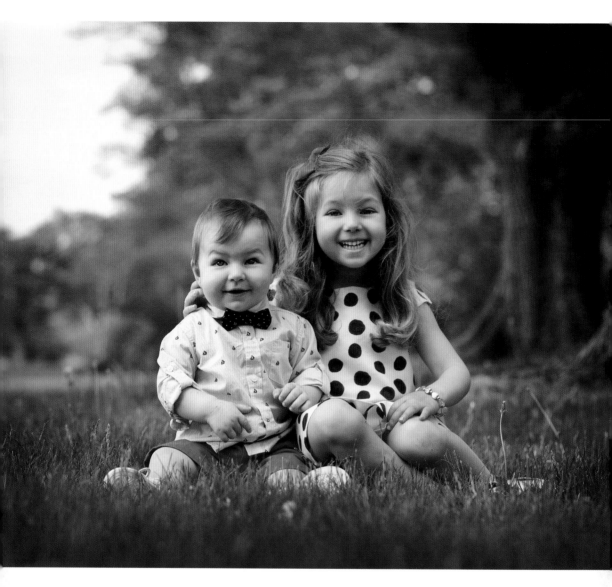

Affection ⬆

I love capturing the affection siblings have for one another in my photography sessions. These two children were so cute as they sat in the grass at their session. We were sitting under tree cover and I used the sky behind the camera as fill.

SPECS > Canon EOS 5D Mark III, 70-200 at 80mm, f/3.5, $\frac{1}{800}$ second, and ISO 320.

A Kiss on the Head ⇩

SPECS > Canon EOS 5D Mark III, 70-200 at 150mm, f/3.5, 1/640 second, and ISO 250.

Then she picked him a yellow flower and sat with him. As he held the flower, she gave him a kiss on the head. A very sweet moment.

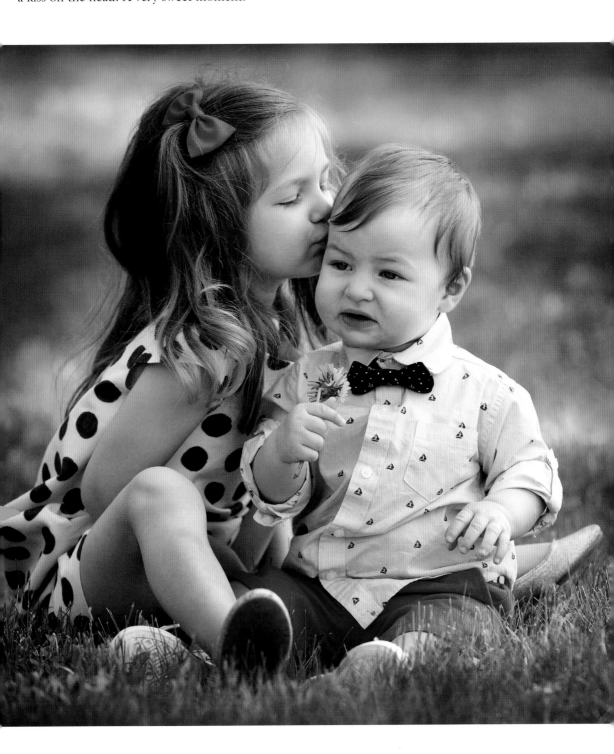

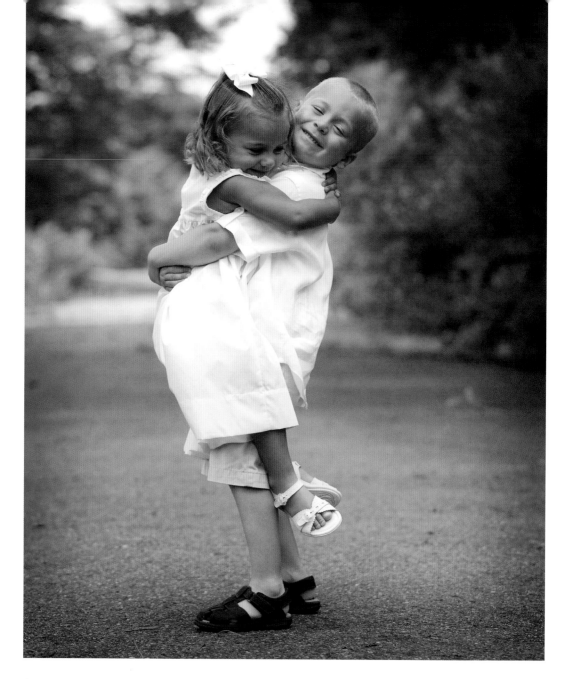

Showing Their Love ⇪

These two show their love for one another at every session I have photographed of them. This particular summer session took place on a very warm July morning. They hugged, Eskimo kissed, and then he picked up his little sister as she hugged him tight. Lit naturally with open sky in front of them.

SPECS > Canon EOS 5D Mark III, 70–200 at 90mm, f/3.5, $\frac{1}{800}$ second, and ISO 200.

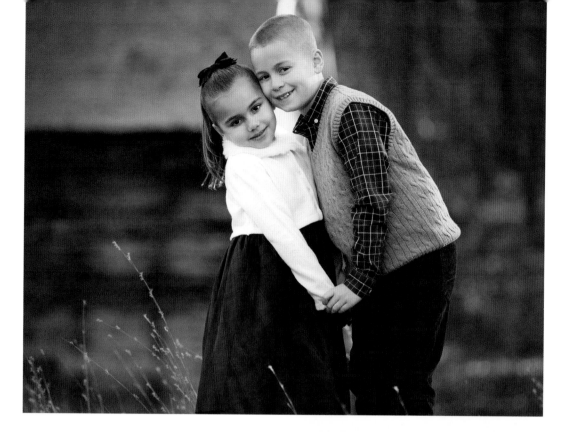

Cheek to Cheek ⇧

Even while looking at the camera, this brother and sister held hands and had their faces cheek to cheek, as they leaned into each other. They were photographed on a November afternoon as the sun was setting just behind the barn.

SPECS > Canon EOS 5D Mark III, 70-200 at 200mm, f/3.5, 1/500 second, and ISO 400.

Then and Now ⇨

These are the same siblings when they were a little younger. They snuggled into each other during their fall holiday session. Their harmonized clothing made them a perfect duo in the fall foliage on this cool, overcast morning. I used available light on one of my favorite paths.

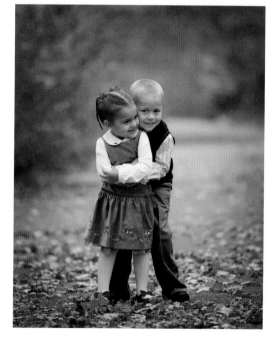

SPECS > Canon EOS 5D Mark III, 70-200 at 200mm, f/2.8, 1/500 second, and ISO 500.

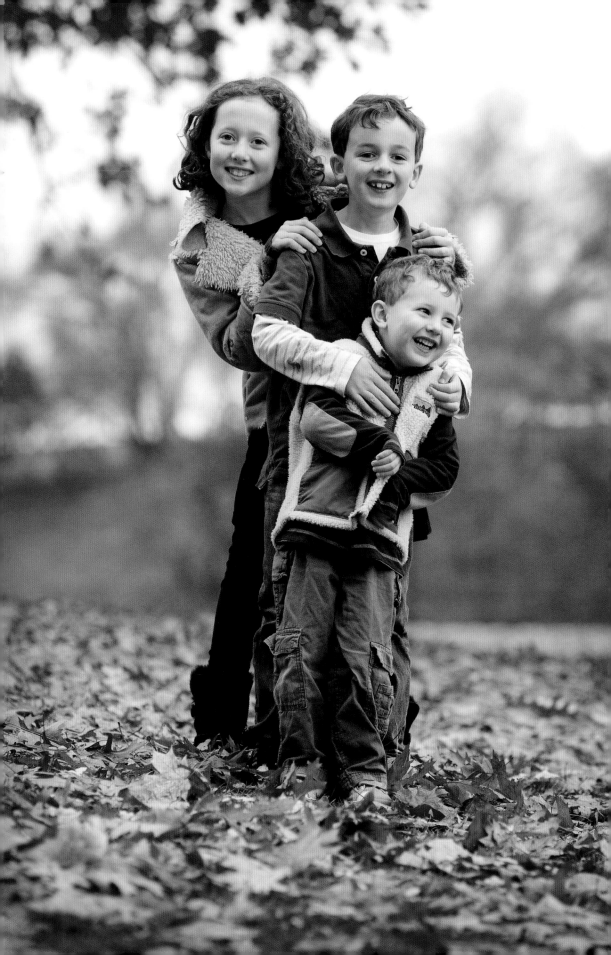

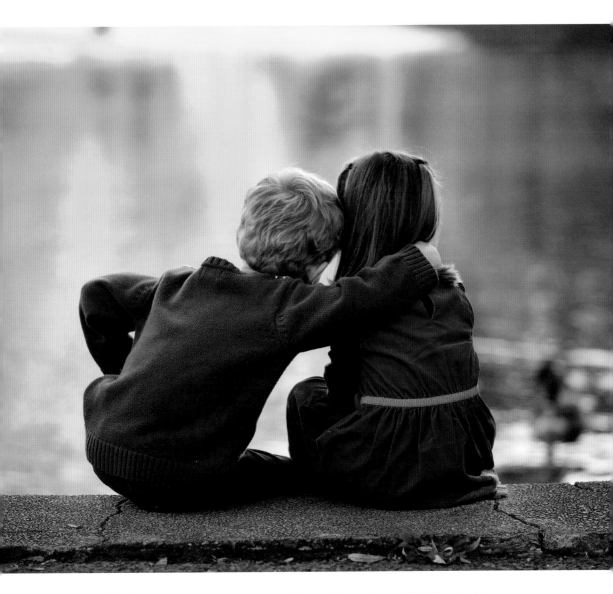

Together and Interacting ⇐

I had these three siblings stand and hold onto each other's shoulders. I did this to keep them all together for a few moments, and also to get them to interact with one another. Laughs began as their big sister would peek out from one side and then the other.

SPECS > Canon EOS 5D Mark III, 70-200 at 135mm, f/3.2, $^{1}/_{500}$ second, and ISO 400.

Hugs For a Beautiful Portrait ⇑

Even a simple, somewhat directed, hug from behind can create a beautiful portrait. This brother and sister were sitting safely on the edge of a pond with mom and dad close by. They sat there for a while and watched the ducks that were swimming nearby.

SPECS > Canon EOS 5D Mark II, 70-200 at 125mm, f/3.5, $^{1}/_{500}$ second, and ISO 320.

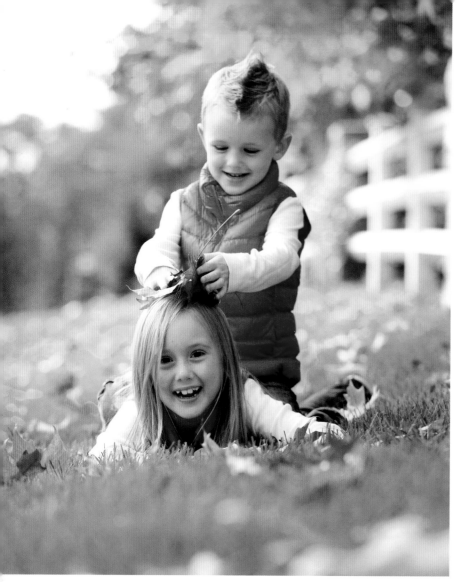

Have Siblings Interact ⇐

A great way to have siblings interact with one another during their sessions is to have them lay on the grass and interact with their surroundings. This session took place during the prime foliage season. We had lots of leaves for them to use as props, which added to the scene.

SPECS > Canon EOS 5D Mark III, 70-200 at 110mm, f/3.5, $\frac{1}{500}$ second, and ISO 320.

Something Fun to Do ⇗

As those two laid down, they started to throw leaves in the air and have fun. This gave them something to do while I captured images of them.

SPECS > Canon EOS 5D Mark III, 70-200 at 95mm, f/3.5, $\frac{1}{500}$ second, and ISO 320.

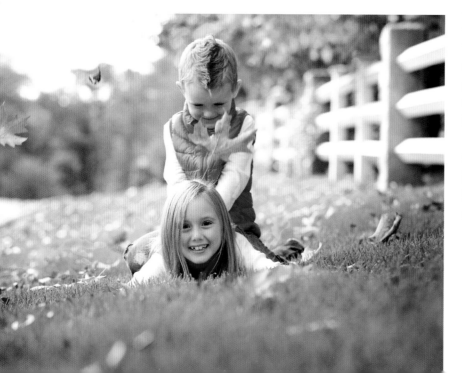

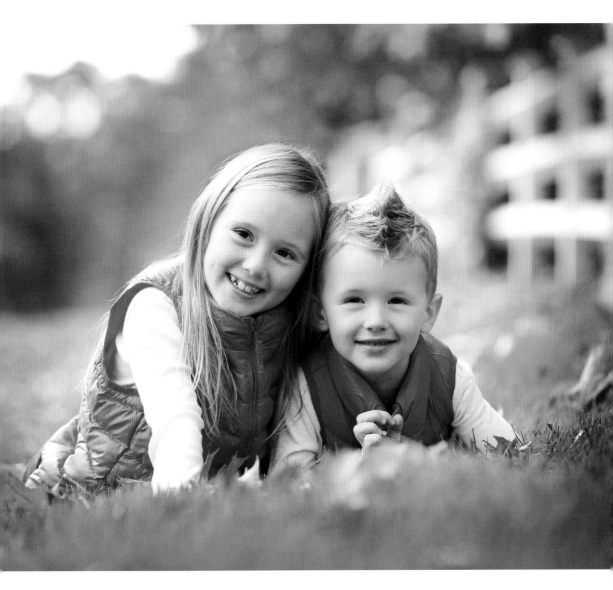

A Few Seconds to Capture ⇪

After letting them have fun in the leaves, I asked them to look my way and smile. It may be brief, but I only need a few seconds to capture a beautiful portrait of two adorable siblings. Lit using available light on an overcast day.

SPECS > Canon EOS 5D Mark III, 70–200 at 155mm, f/3.5, $1/500$ second, and ISO 320.

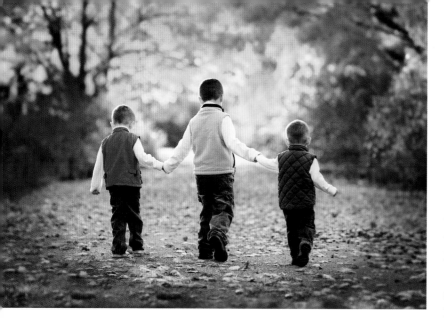

The Yellow Leaf Road ⇦

The leaves were perfect this day for these three brothers. When we arrived at the park, I asked them to hold hands and follow the yellow leaf road. I knew they were very into *The Wizard of Oz* movie, so it worked perfectly. It was a late October afternoon, and the sun was setting fast behind the path they walked along.

SPECS > Canon EOS 5D Mark II, 70-200 at 155mm, f/3.5, 1/500 second, and ISO 250.

A Beautiful Light from Behind ⇦

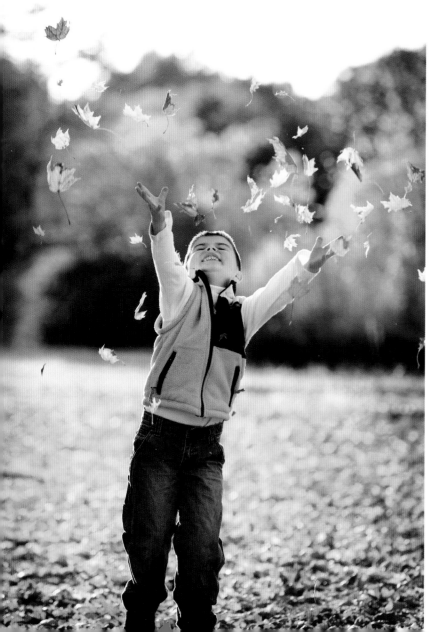

After capturing the three of them together, I let each child play in the leaves. The light was beautiful coming in from behind them and it lit each leaf as it was thrown into the air.

SPECS > Canon EOS 5D Mark II, 70-200 at 200mm, f/4, 1/500 second, and ISO 320.

A Colorful Element ⇨

The fall adds a colorful element to children sessions. Setting sun and a reflector for fill light were a great combination for this twins session. Sitting them on an overturned bucket, I had them lean into each other and look my way.

SPECS > Canon EOS 5D Mark II, 70–200 at 90mm, f/3.5, $^{1}/_{500}$ second, and ISO 250.

A Reflector for Fill ⤵

After getting a few poses done, I then let them walk down the path toward me. I still have my reflector in place for fill, since the sun was setting fast. Even though they aren't looking at the camera, they were in conversation and smiling.

SPECS > Canon EOS 5D Mark II, 70–200 at 160mm, f/3.5, $^{1}/_{500}$ second, and ISO 250.

Four Sisters ⬇

I started this four-sisters session with them taking a walk in the path covered in leaves. I just love the moment their one-year-old sister looked back at me and smiled. I used natural light with no fill. It was an overcast day with open sky lighting illuminating the back and front of the girls and the tree covered path.

SPECS > Canon EOS 5D Mark II, 70–200 at 70mm, f/4.5, $\frac{1}{500}$ second, and ISO 320.

I just love the moment their one-year-old sister looked back at me and smiled.

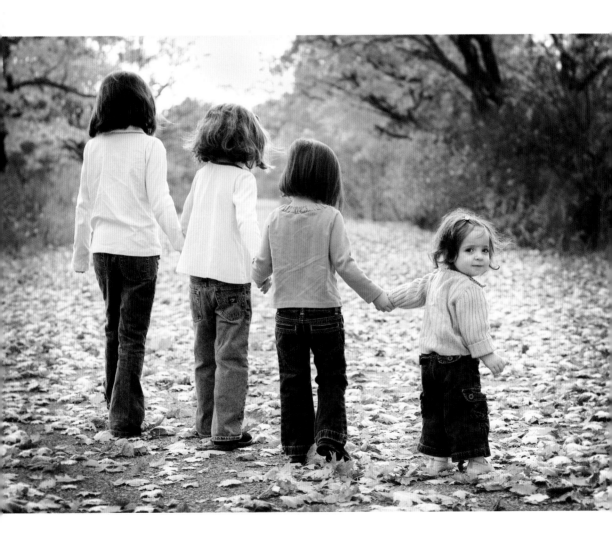

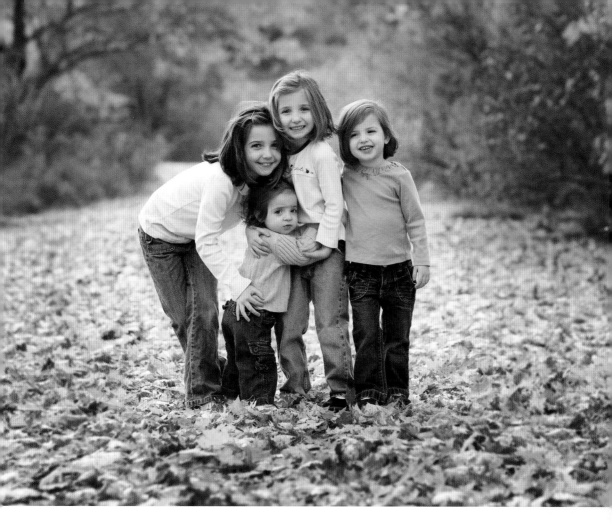

Moving Keeps Them Engaged ⇧

As the girls walked a bit, I asked the older girls to turn around and hug each other. The youngest sister snuggled right into them. The girls' ages were seven, five, three, and one year.

SPECS > Canon EOS 5D Mark II, 70-200 at 105mm, f/4, $^1/_{500}$ second, and ISO 320.

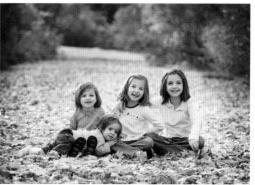

All Together ⤸

The girls all sat together in the leaves on the path as their youngest sister laid across their laps. A very fun moment, as the older three smiled. I allowed the session to be fun, and moving along was key to keeping children of various ages engaged.

SPECS > Canon EOS 5D Mark II, 70-200 at 135mm, f/4, $^1/_{500}$ second, and ISO 320.

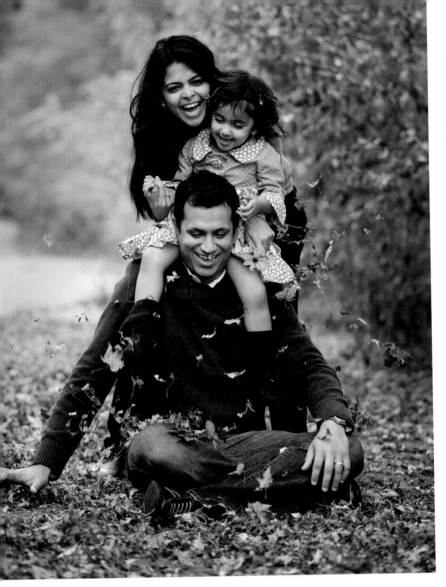

Into the Leaves ⇦

Leaves are great during family sessions. Especially when the parents don't mind getting into the leaves and covered in them. As this family sat on the leaf-covered path, dad started throwing leaves into the air.

SPECS > Canon EOS 5D Mark II, 70–200 at 102mm, f/2.8, 1/500 second, and ISO 400.

Journalistic Sessions ⇱

I typically have two camera bodies with different lenses on my arms when I shoot journalistic sessions like these. I can easily go back and forth with ease, as I did in my news days. I watched as the family interacted with their daughter in the leaves and loved capturing all the fun they were having.

SPECS > Canon EOS 5D Mark III, 135mm, f/3.2, 1/500 second, and ISO 400.

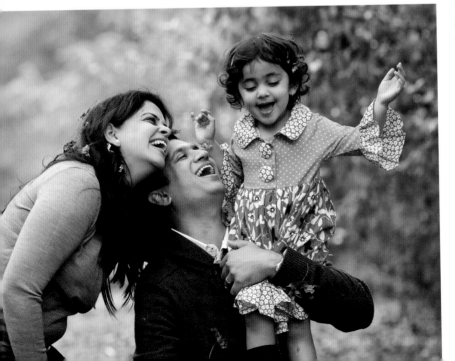

Capture
the Peak Action ⇒

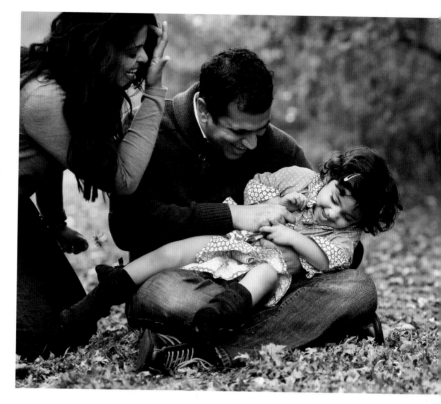

The laughs turned into full-out contagious giggles as they tickled their daughter while sitting in the leaves. I don't stop or interrupt the session, I sit back with my cameras far enough away for them to almost forget about me, but close enough to capture the peak action.

SPECS > Canon EOS 5D Mark III, 70–200 at 200mm, f/3.2, $1/500$ second, and ISO 400.

Key Motions
Are Clues ⇒

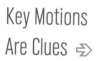

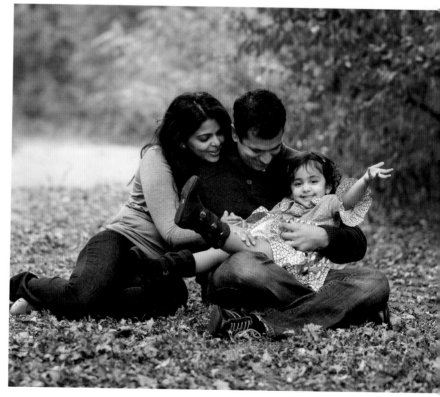

Once the little girl raised her arm into the air, I knew this part of the session was done. I like to keep things moving, so no one gets bored. I look for key motions like these to confirm that it's time to move onto something else.

SPECS > Canon EOS 5D Mark II, 70–200 at 90mm, f/2.8, $1/500$ second, and ISO 400.

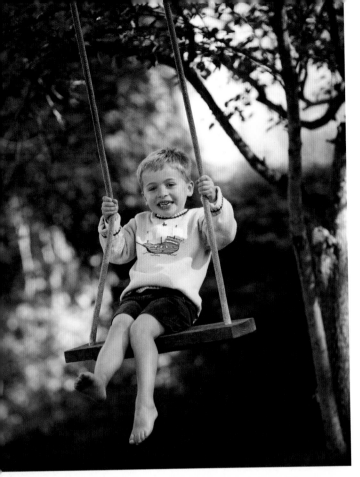

A Starting Place ⇐

When you arrive at a new-session location, you never know what might be there. This session started at a family's house near a beach in early fall. I was prepared for colder weather and full sun. When I saw this awesome rope swing, I knew this was going to be a fun session. I had the four-year-old start there. With little prompting, he started swinging away and smiling, as he wanted to show me how high he could go.

SPECS > Canon EOS 5D Mark II, 70-200 at 200mm, f/4, ¹/₅₀₀ second, and ISO 320.

Be Ready with another Camera and Lens ⇐

After swinging a bit, his mom took his sweater off and he laid down on the ground. He looked up and smiled at me. I'm pretty sure there were tickles being given to bring out that genuine smile too. I had my second camera body ready to go with a wide-angle lens to give a different perspective as I shot from over head, zooming in a bit.

SPECS > Canon EOS 5D, 24-70 at 46mm, f/3.2, ¹/₆₄₀ second, and ISO 320.

Moving to
a Second Location ⇛

After spending some time at their home, we headed to the beach across the street. I had mom stay just behind me as I photographed him holding a boat, as he made his way down the path to the beach.

SPECS > Canon EOS 5D Mark II, 24-70 at 24mm, f/5.6, $^1/_{500}$ second, and ISO 200.

I had my second camera body already to go with a wide-angle lens to give a different perspective.

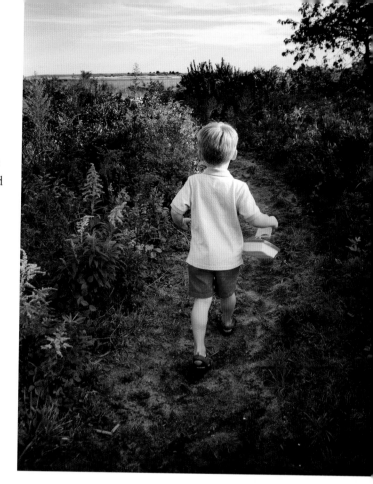

Zoom in to Capture Activity ⇛

Once at the beach, he stopped to use a clam shell to dig in the wet sand. The way the sunlight lit him from the right side was beautiful. I zoomed in to capture him digging and letting the wet sand drip off the shell.

SPECS > Canon EOS 5D Mark II, 70–200 at 140mm, f/4, $^1/_{500}$ second, and ISO 100.

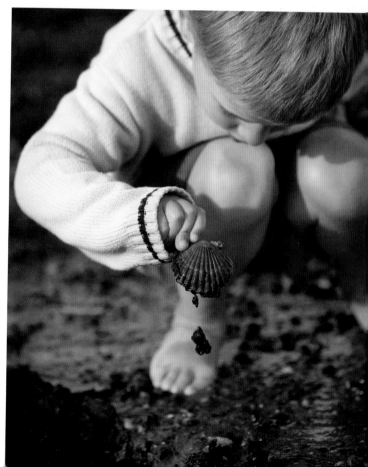

Doing It Over and Over Again ⇦

The beach location offered a nice, shallow low tide, and it was great for him to go into the water and play sailor. He would push the boat off to sail, and it would slowly take off. What's great about children is they will do things over and over again until they are bored. So if you miss it the first time, you can be sure they will do it again right after.

SPECS > Canon EOS 5D Mark II, 70-200 at 75mm, f/4, $\frac{1}{400}$ second, and ISO 100.

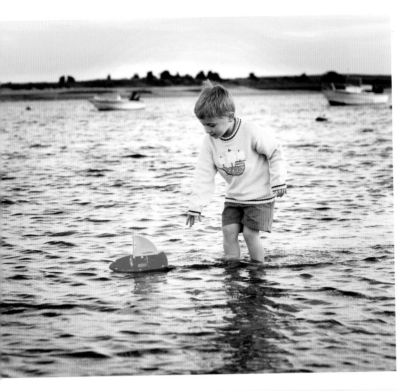

Multiple Angles ⇦

He then changed his direction to sail the boat away from the camera. I loved how he went safely into the calf-deep water and did this. Usually children stay on shore and you are limited to the angles you can capture of them doing this.

SPECS > Canon EOS 5D Mark II, 70-200 at 95mm, f/4, $\frac{1}{500}$ second, and ISO 100.

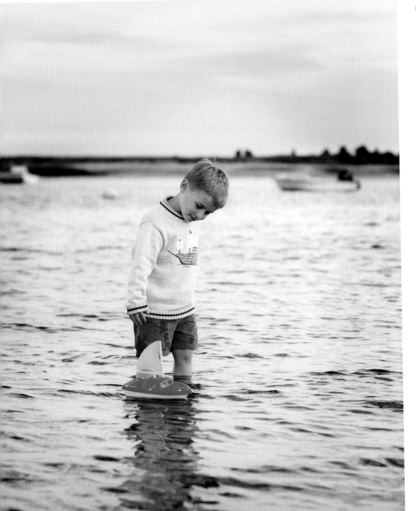

A Great Place to Sit ⇧

Continuing with this on-location session, a collection of boats laying on the sand made a great backdrop for him to pose in front of. He sat down and looked toward the camera. He would kick up sand and smile in my direction.

SPECS > Canon EOS 5D Mark II, 70–200 at 153mm, f/4, $^{1}/_{500}$ second, and ISO 200.

A Warm Tone from the Setting Sun ⇩ A Great Ending ⇨

This four-year-old loved to act out being an airplane. Without any prompting, he started to act it out as he ran along the path away from the beach. The sun was setting, and it added a nice, warm tone to the image.

SPECS > Canon EOS 5D Mark II, 70-200 at 105mm, f/4, 1/800 second, and ISO 200.

As the session came to an end, Mom put a sweater on him and he stood out in the grass right near the marsh. He then started motioning with his arms spread out that we were all done. What a great ending!

SPECS > Canon EOS 5D Mark II, 70-200 at 200mm, f/5, 1/800 second, and ISO 125.

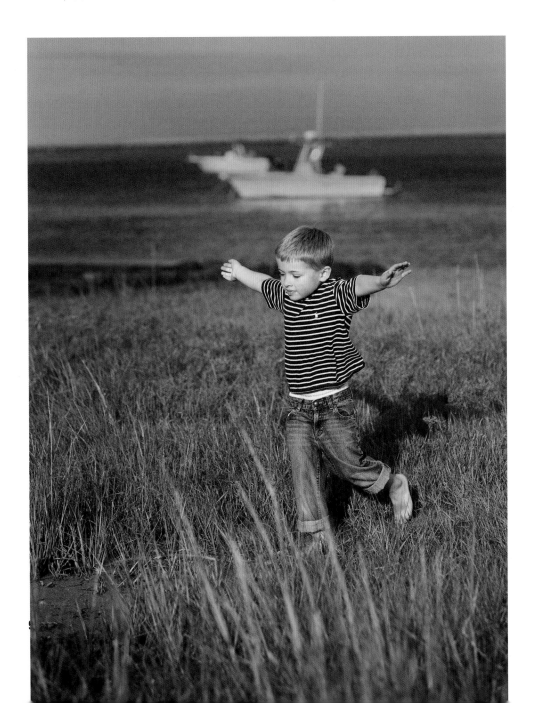

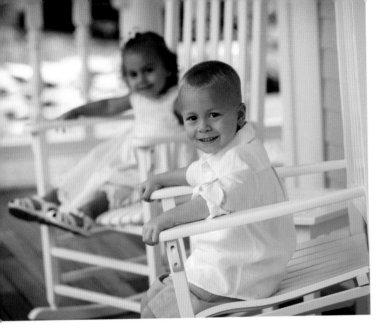

Photographing Children at Their Home ⇦

Photographing children at their homes can be a lot of fun. They are comfortable in their surroundings, and there are familiar props at the home you can use during the session. I started photographing this brother and sister who were four and two years old on their front porch. They had a great set of rocking chairs that were perfect to start the session and get them laughing and smiling.

SPECS > Canon EOS 5D Mark II, 70-200 at 135mm, f/3.5, 1/500 second, and ISO 250.

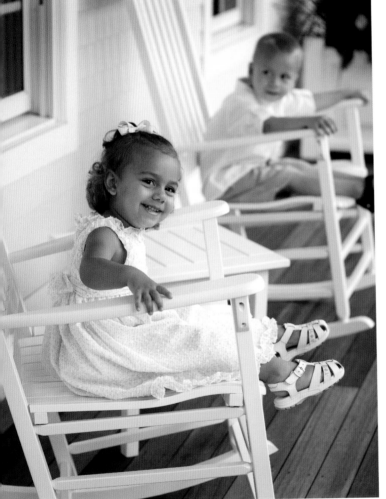

Photojournalistic Style ⇦

I moved from the other side of the two kids so I could have the little girl in focus and brother out of focus. While capturing them rocking back and forth, I kept my photojournalistic style featured for this session.

SPECS > Canon EOS 5D Mark II, 70-200 at 70mm, f/3.2, 1/500 second, and ISO 320.

Open Shade on the Porch ⇒

Sessions at homes offer a lot of little areas to use with natural props. On this porch, they had a nice railing that their little girl really liked looking over. She kept smiling at her brother who was sitting on the front steps. I took advantage of the nice, open shade, using the sky in front of the porch for fill.

SPECS > Canon EOS 5D Mark II, 70–200 at 135mm, f/3.5, ¹⁄₅₀₀ second, and ISO 320.

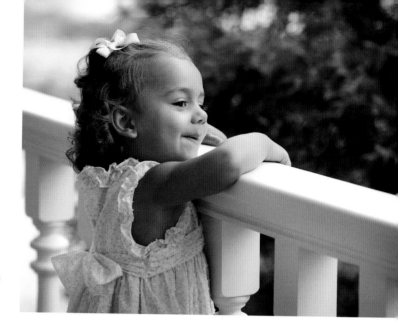

Happiness and Giggles ⇒

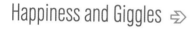

After capturing images of his little sister, I moved down to the front of the porch where the little boy was sitting. He was so happy and giggled away as I photographed him.

SPECS > Canon EOS 5D Mark II, 70–200 at 135mm, f/3.5, ¹⁄₈₀₀ second, and ISO 250.

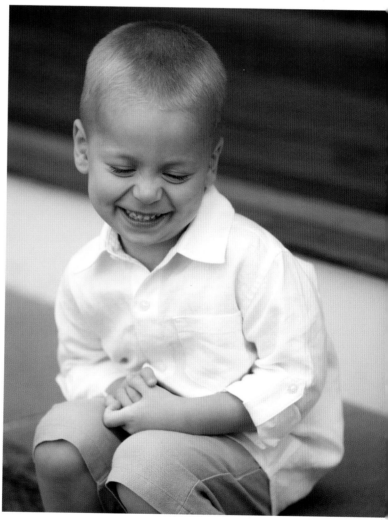

Get to Know You ⇒

The front steps of a family's home is wonderful to use as a place to let a little one sit. I was photographing this family of three on these steps when I began to focus on their two-year-old daughter. She was prompted to do peek-a-boo to get her to open up to me a bit more.

SPECS > Canon EOS 5D Mark II, 70–200 at 150mm, f/3.2, ¹/₅₀₀ second, and ISO 320.

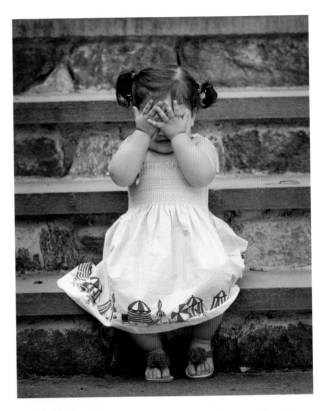

A Peek-a-Boo ⤵

She then began to peek out of one eye and I kept on shooting, waiting for her to open up to me a bit more and smile.

SPECS > Canon EOS 5D Mark II, 70–200 at 155mm, f/3.2, ¹/₅₀₀ second, and ISO 320.

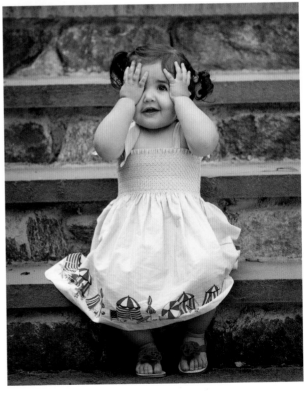

Happy Expression ⇒

At this moment *(facing page)* she put her hands down at her side and gave us a big smile. I loved the expression, and it was okay that she didn't look right at the camera. The happy expression was key to this moment, not the eye contact.

SPECS > Canon EOS 5D Mark II, 70–200 at 135mm, f/3.2, ¹/₅₀₀ second, and ISO 320.

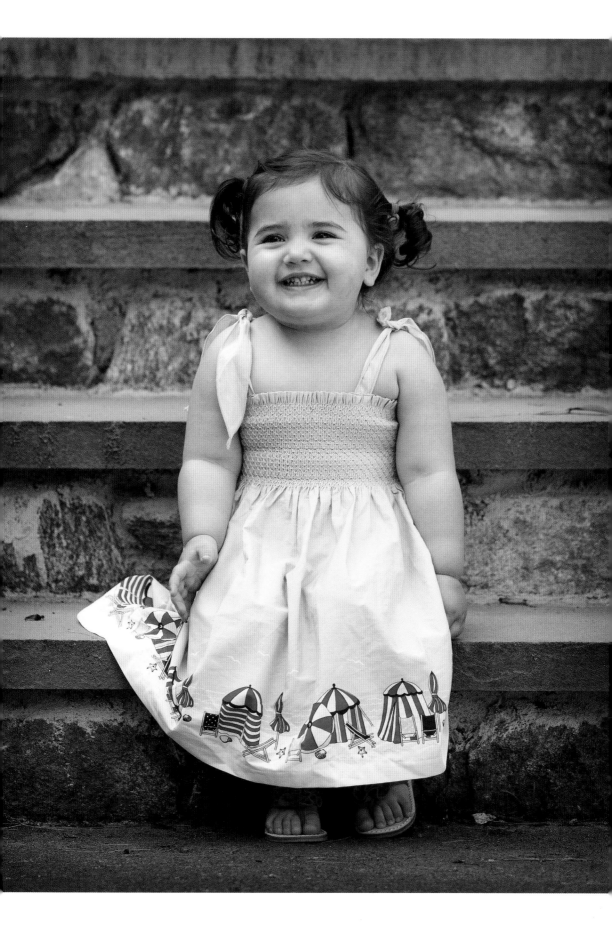

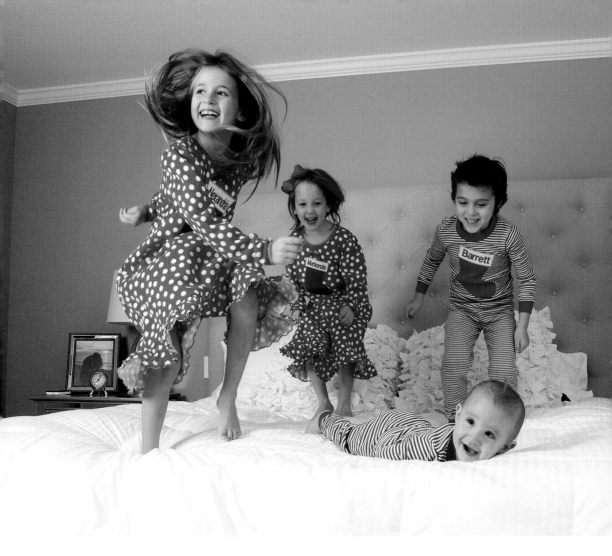

A Favorite Location ⇧

When the weather gets colder, clients like me to come to their home and do sessions at their location, rather than come into my studio. It's great as I can use a bedroom or their children's favorite location to take their portraits. I still use my journalistic skills, even indoors. For this particular session, I was there at a holiday time to photograph their new baby (not in this photo). I had photographed the three older children jumping on a bed the previous year during their youngest brother's newborn session. So we had them do it again. What kid is going to say no to jumping on a bed? I let them jump away and have fun as I fired off shots of them in action. This image is lit with a 3x4-foot softbox at camera left, and an umbrella camera right, using AlienBees and AB800 flash units. The lights were synced with my Pocket Wizard Transceiver II—one on the camera and one on the flash unit.

SPECS > Canon EOS 5D Mark III, 24-70 at 24mm, f/8, $^{1}/_{160}$ second, and ISO 100.

Capture Their Pauses ⇒

Those little breaks during sessions in a home can offer a beautiful portrait as well. This eighteen-month-old went over to look out a window when we were switching gears to another place in their home. As he looked out, I positioned myself to keep him to the far left. The window ledge leads the eye into the frame. He was only there for a few frames, but long enough to capture this portrait of him and a slight reflection in the window.

SPECS> Canon EOS 5D, 85mm, f/2.8, ¹/₂₅₀ second, and ISO 500.

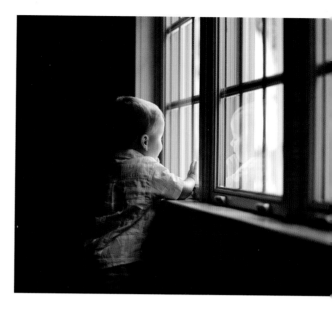

The Things They Love ⇩

I also like to watch children play with the things they love. This happened to be a piano in the foyer of their home. I got up high, shooting from over their stair railing. The keys on the piano and the tile on the floor worked well in this image, as the three-year-old and one-year-old tapped on the keys and looked up at me every so often.

I lit this with an AlienBees AB800 flash unit in a 3x4-inch softbox directed from the left side of the camera. Light and camera were synced via a Pocket Wizard Transceiver II.

SPECS> Canon EOS 5D Mark III, 24-70 at 43mm, f/6.3, ¹/₁₆₀ second, and ISO 160.

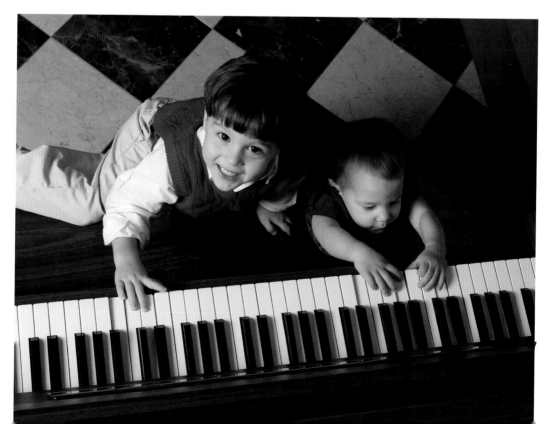

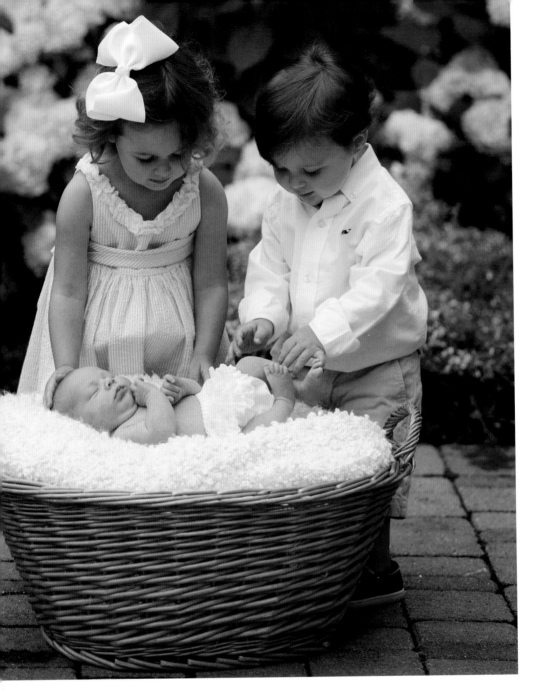

A Parent or Assistant
Should Always Be Near ⇪

A four-year-old sister and two-year-old brother watch their two-week-old baby sister. I photographed them on the front path of their home on a warm summer day. I had the other sister look for her hands and asked the two-year-old to find her toes. I was very fortunate they did it at the same time and safely. I always have a parent or an assistant close by for safety.

SPECS > Canon EOS 5D Mark III, 70–200 at 120mm, f/3.5, ¹⁄₆₄₀ second, and ISO 250.

*So I kept her in the
frame as she made
her way . . .*

Two Subjects with
Selected Focus ⇛

I met a family up at their beach house for
this session. We were photographing their
daughters, one who was just about three
months old. I planned on doing a few baby-
in-the-basket images on the boardwalk that
led from the house to the beach. I could see
their older daughter running toward me in
the background. So I kept her in the frame
as she made her way down the path, with her
sister sound asleep in the basket.

SPECS > Canon EOS 5D Mark II, 70–200 at 70mm,
f/4, ¹/₅₀₀ second, and ISO 400.

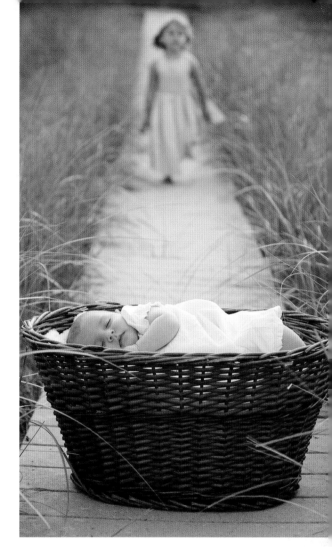

A Zoom Lens
Follows the Action ⇛

When she approached the basket, she
stopped, checked on her baby sister, and gave
her a little love. I kept on shooting through-
out her journey down the path to capture a
whole series of her running and stopping. I
started out at 70mm and then zoomed in to
150mm to continue capturing the action.

SPECS > Canon EOS 5D, 70–200 at 150mm, f/3.5, ¹/₅₀₀
second, and ISO 400.

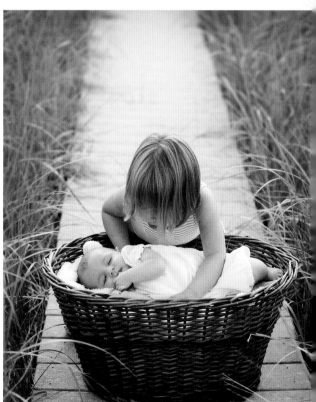

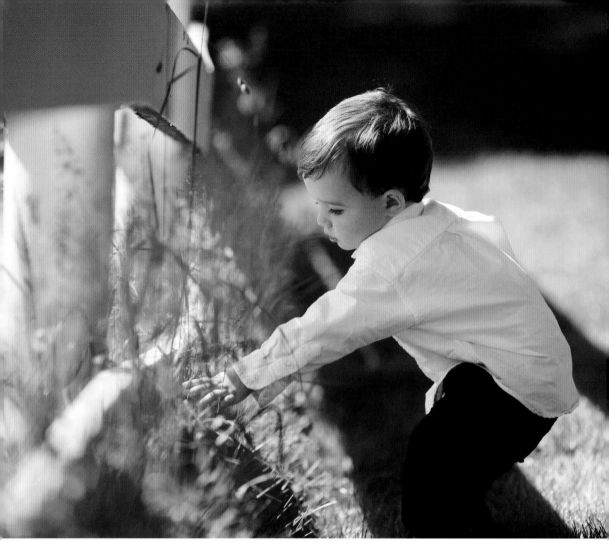

Finding the Right Light ⬆

S PECS > Canon EOS 5D Mark II, 70–200 at 200mm, f/3.5, $\frac{1}{500}$ second, and ISO 200.

Capturing those in-between moments at a session are so important. This moment can be when a one-year-old boy takes a break to explore, looking and darting his way to discover the tall grasses along a fence. I still need to watch for and find the right light as a child explores. This one-year-old is being lit from the sun coming in from behind him at camera left, and being filled at front with the light bouncing off the white fence. I love how the fence leads you into him and the shadows from the fence come in from behind.

Noisemakers to Get Attention ⇒

Another one-year-old who needed a little break during his session with his siblings. He's sitting on of my suitcase props and squeaking one of my noisemakers I use to get children's attention. The light was just gorgeous as he sat along side an old barn. I used a reflector to bounce some light back onto his face.

SPECS> Canon EOS 5D Mark III, 70–200 at 110mm, f/3.5, $\frac{1}{500}$ second, and ISO 320.

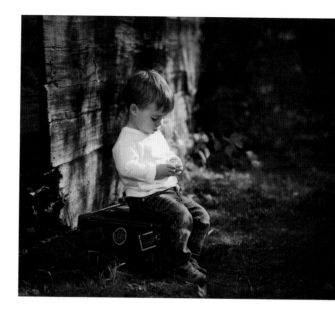

Photographic Access ⇩

As he sat there squeaking that little toy, he would look around the corner of the barn to see if his siblings could hear him, ignoring me and my camera. The moment, where he was not mindful of me and the camera, granted me photographic access.

SPECS> Canon EOS 5D Mark III, 70–200 at 105mm, f/3.5, $\frac{1}{500}$ second, and ISO 320.

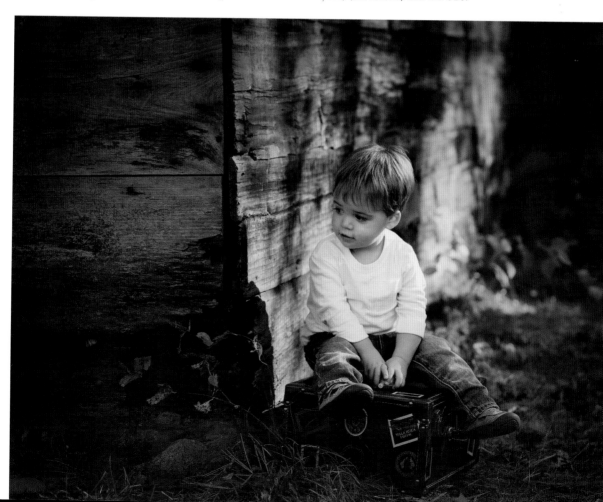

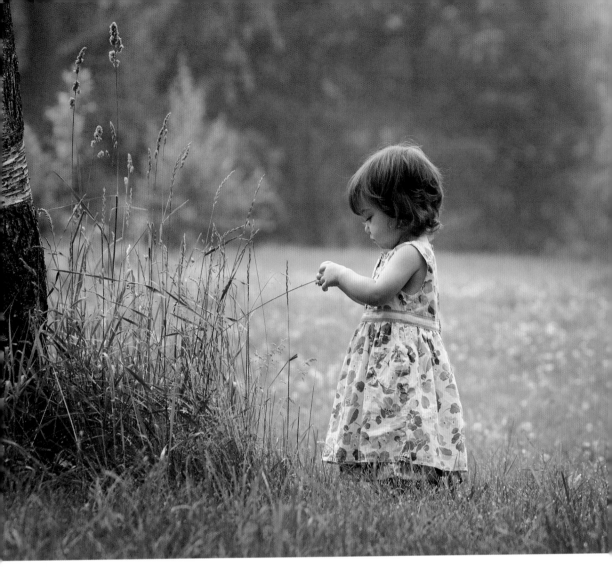

Time to Discover ⇧

Children are drawn to grass, flowers, and weeds. Let them discover what is at the location. These moments can create a beautiful portrait. As this eighteen-month-old child walked around at this park, she went up to a cluster of grass and pulled on the flower spikes. The morning was foggy and was beginning to clear, and the light lit her from behind with open sky behind the camera.

SPECS> Canon EOS 1D Mark III, 70-200 at 90mm, f/3.2, 1/500 second, and ISO 400.

Capturing Moments of Discovery ⤴

At this discovery moment (*facing page top*), the four-year-old little girl was being handed wild flowers from her big brother. He had picked them for her. As she held out her hand for more, I kept capturing moments between these two siblings to see what would unfold next.

SPECS> Canon EOS 5D Mark II, 70-200 at 150mm, f/4, 1/800 second, and ISO 200.

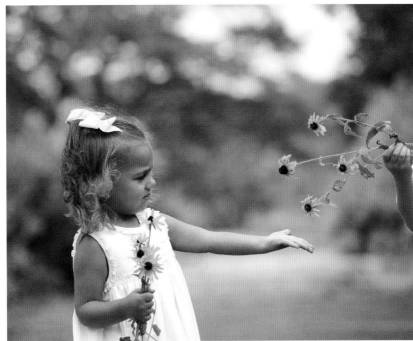

Looking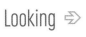

The little girl headed over to one of my suitcase props and sat, looking down at the beautiful flowers her brother had just picked for her.

SPECS > Canon EOS 5D Mark II, 70–200 at 155mm, f/3.5, $\frac{1}{800}$ second, and ISO 200.

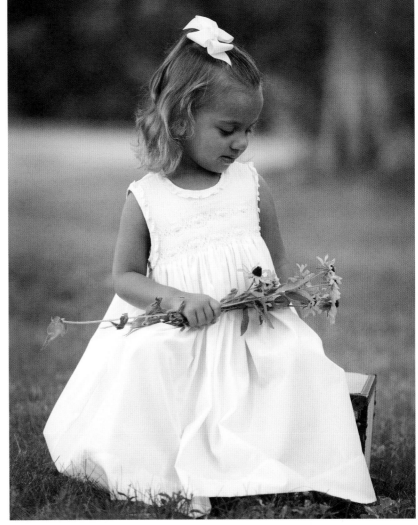

"Look at Me" ⇩

This three-year-old brother tried so hard to get his sister to look at him as she was holding a wild flower that was found in the field. I loved how he really tried to get her attention. It was a sweet moment.

SPECS > Canon EOS 5D Mark III, 135mm, f/2.8, ¹⁄₄₀₀ second, and ISO 320.

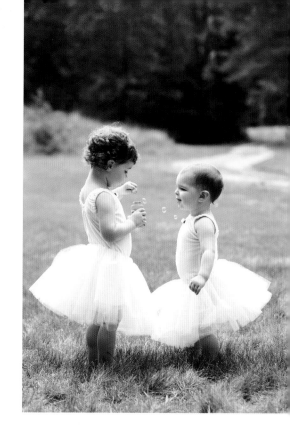

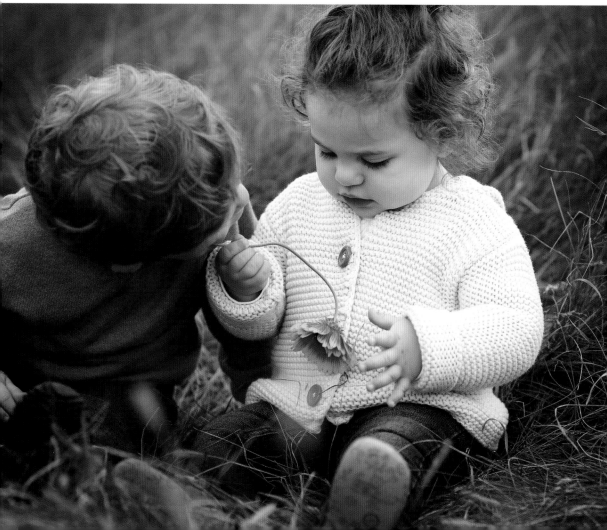

Recording the Awe ⇐

These two sisters entertained each other throughout their session. At this moment, the older one started to blow bubbles toward her younger sister. I loved how the younger one just stood there and watch in awe, amazed that her sister was able to blow bubbles like her parents could.

SPECS > Canon EOS 5D, 85mm, f/3.5, $\frac{1}{500}$ second, and ISO 200.

Backlit Bubbles ⇒

Bubbles work great for children at any age. It helps to keep the session fun. This eighteen-month-old little girl tried to pop each bubble that shot out of my studio bubble maker. I only use it outdoors as it throws thousands of bubbles out at a time, and can be a sticky mess in a studio environment. I moved

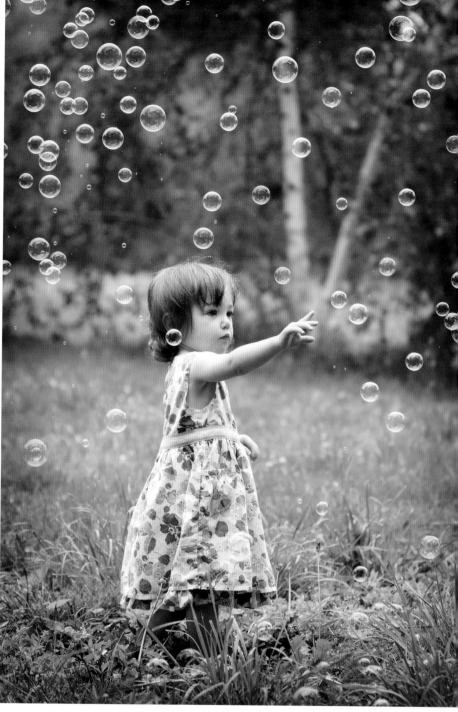

around her so the bubbles would be back lit and really show up in the images.

SPECS > Canon EOS 1D Mark III, 70–200 at 70mm, f/2.8, $\frac{1}{500}$ second, and ISO 400.

Offer a Captivating Location ⇩

This location offers an old wood fence that children are drawn to. There is an old grist mill (red wheel) that they love to watch go round and round. When I notice the child is going over there, I will situate myself on the side of them, I like to see their face and the lines of the fence as they peer at the wheel.

Once I know their attention is on the wheel, I can move around to an area where I can capture the front of their face. I will zoom in or just switch to my other camera body and lens that I have on me. The child will notice me or I will have a parent come with me to call their name. They usually don't even notice us at first, but when they do, then look up and smile for a few frames.

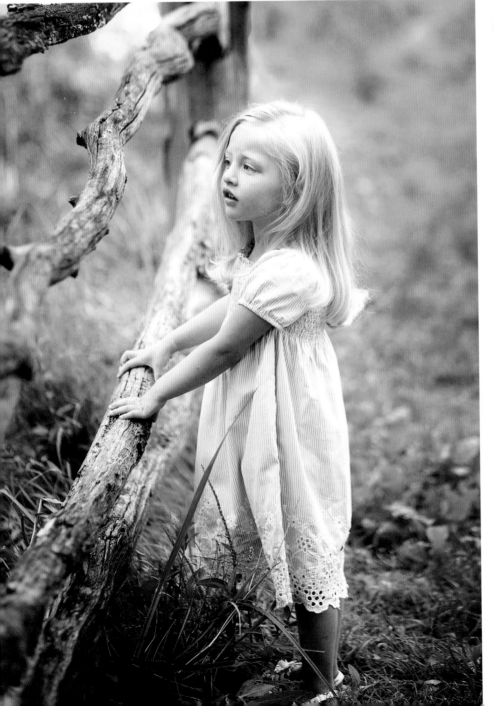

SPECS > Canon EOS 5D, 85mm, f/1.8, $1/500$ second, and ISO 400.

Different Heights of Fence Rails

Even the youngest of walking children love to look through at the grist mill. They talk to it and look back at their parents to make sure they see it too. The fence has many different heights for children to peer through as well.

SPECS > Canon EOS 5D, 70-200 at 168mm, f/3.5, $\frac{1}{500}$ second, and ISO 320.

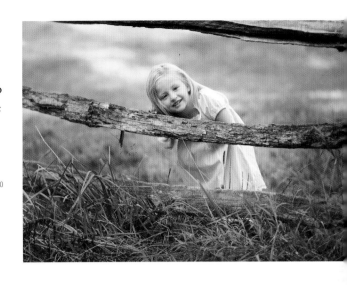

No Prompting Needed

I can then back up as all the siblings gather to look at the grist mill. This makes for a great way to end their session, with them all together in one place, posed naturally. No prompting from me.

SPECS > Canon EOS 5D Mark III, 70-200 at 70mm, f/3.5, $\frac{1}{500}$ second, and ISO 400.

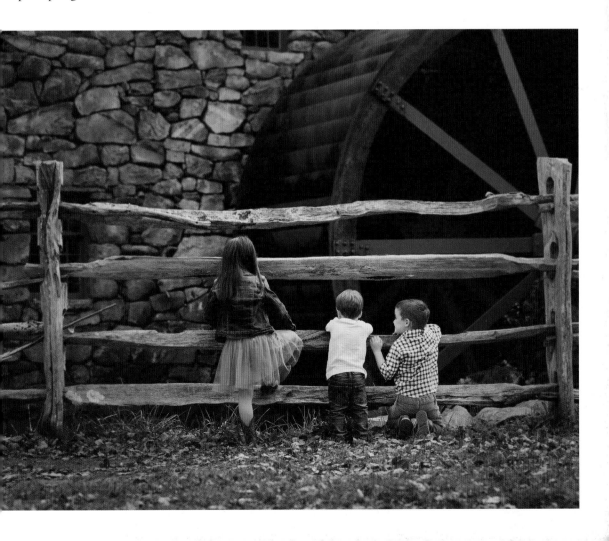

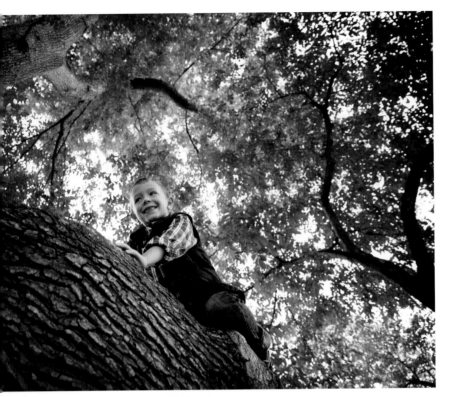

Angle to Exaggerate Size and Height ⇐

Climbing a tree during a session brings back memories to childhood days. When there is a tree that is at a child's height to climb, I will get down low and shoot wide. It makes it look like the tree is bigger and higher than it really is. It offers a nice slice-of-life moment to a session's images.

SPECS > Canon EOS 5D Mark II, 24-70 at 400mm, f/2.8, $^1/_{250}$ second, and ISO 400.

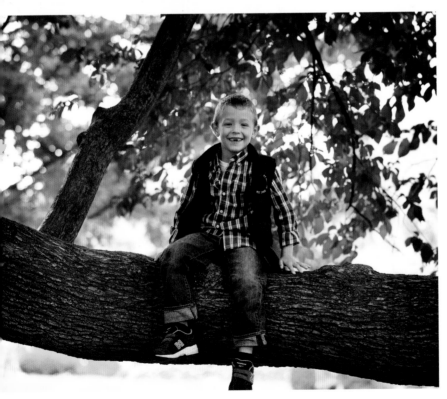

Switch to a Telephoto Lens ⇐

You can capture a few portraits by calling the child's name. They love to look your way and tell you how high they are. This particular tree limb was a few feet off the ground and I switched to my longer lens to soften and condense the tree leaves into the background.

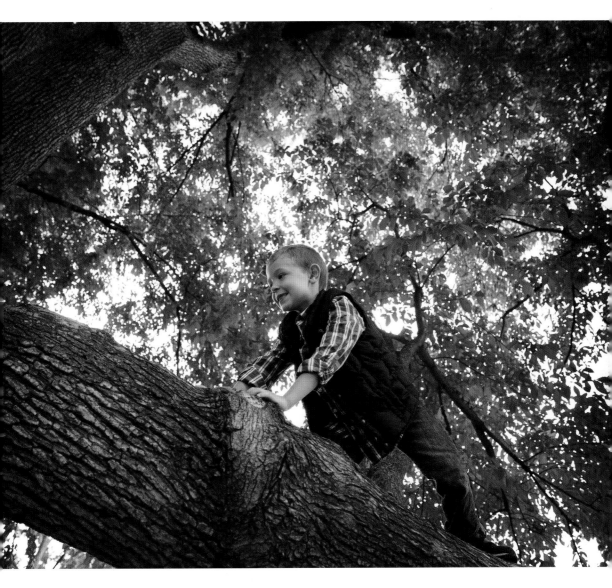

SPECS > Canon EOS 5D Mark III, 70–200 at 123mm, f/3.5, $^1/_{200}$ second, and ISO 400.

A Dramatic Feel ⇧

Keeping the angle wide and low can add a nice dramatic feel to the tree climbing.

ECS > Canon EOS 5D Mark II, 24-70 at 24mm, f/3.5, $^1/_{250}$ second, and ISO 400.

Discovering ⬇

These seventeen-month-old twins could only sit in the wagon for so long for portraits. So we let them go out into the field and discover the wildflowers growing. Dandelions galore make for nice images as the children picked their way through the grass.

SPECS > Canon EOS 5D Mark III, 70-200 at 105mm, f/3.5, 1/640 second, and ISO 250.

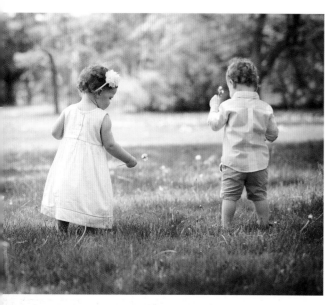

Mom Is Just out of the Frame ⬇

As the twins picked their flowers, each one would take turns looking back at us. I love this one particular moment when the little girl looked up at her mom (just out of frame). It was just a moment after the image above.

SPECS > Canon EOS 5D Mark III, 70-200 at 105mm, f/3.5, 1/640 second, and ISO 250.

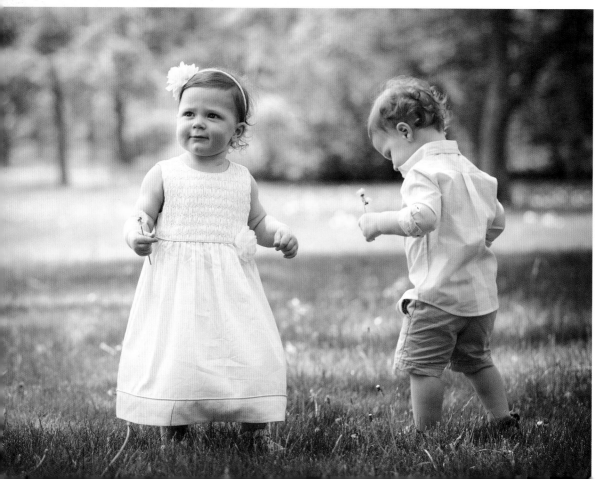

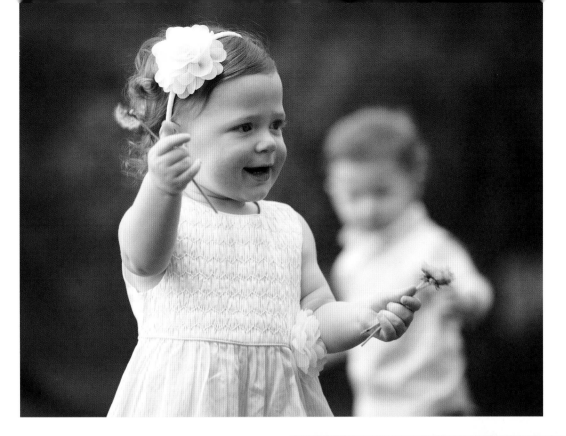

Zoomed In ⬆

I zoomed in on the girl as she walked over to show her dad (he's just out of the frame), while keeping her twin brother in the background.

SPECS > Canon EOS 5D Mark III, 70–200 at 182mm, f/3.5, $\frac{1}{640}$ second, and ISO 250.

Overcast Sky Filters the Light ⇒

The brother continued out into the field to pick more flowers as his sister walked out of frame. I loved the springtime feel to the colors he was wearing and the background. The sky was a bit overcast, so it helped to filter what would have been full sun.

SPECS > Canon EOS 5D Mark III, 70–200 at 175mm, f/3.5, $\frac{1}{640}$ second, and ISO 250.

Piggyback Ride Pose ⇐

Piggyback rides are great for siblings, young and old. It also helps those older siblings who are past the Eskimo kisses and hugging stage. It keeps them connected and you can get a few smiles out of them.

SPECS > Canon EOS 5D Mark III, 70–200 at 123mm, f/3.5, $^1/_{500}$ second, and ISO 400.

An Interactive Pose ⇑

When children can sit on their parents shoulders, it makes for a fun, interactive portrait. The children look at one another and the parents smile.

SPECS > Canon EOS 5D Mark II, 135mm, f/4, $^1/_{500}$ second, and ISO 200.

More in-between Moments ⬆

SPECS > Canon EOS 5D, 70–200 at 85mm, f/3.2, $^1/_{500}$ second, and ISO 320.

Those in-between moments when a child thinks the session is on break or you aren't taking photographs, can be wonderful. This little girl who was about three years old, laid down on a stone for a break after walking with her younger sister. I loved how she rested her head on her hand and looked up toward mom and dad just outside the frame. The light that fell into her eyes from the open sky was beautiful.

During a Break ⇩

This image is from a break in taking photographs and before a clothing change. The four-year-old little boy sat up against an old shed behind the home. I loved how the overgrown bushes naturally framed him and he grabbed his foot, as if he was in a personal time out.

SPECS > Canon EOS 5D, 200mm, f/3.5, $\frac{1}{500}$ second, and ISO 200.

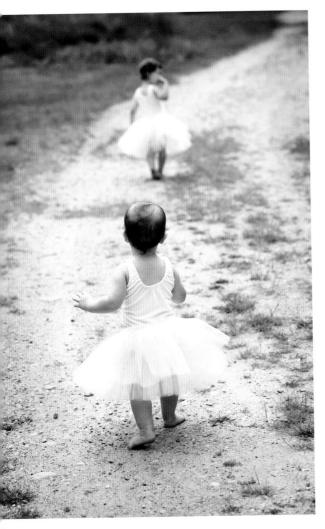

Follow the Leader ⇐

Playing follow the leader with siblings can help to guide the session into more images as it comes to an end. As big sister waved goodbye to her younger sister, she was determined to catch up. I photographed them as they continued down the path. I loved the moment the younger one placed her right foot onto the path offering leading lines into and out of the frame.

ECS > Canon EOS 5D, 70-200 at 153mm, f/4, ¹⁄₁₂₅₀ second, and ISO 200.

Down the Path ↺

I photographed this boy as he skipped down the path. I loved that I was able to catch the moment that his high right foot was going down as his left foot is just leaving the ground.

SPECS > Canon EOS 5D, 24-70 at 24mm, f/4, ¹⁄₅₀₀ second, and ISO 250.

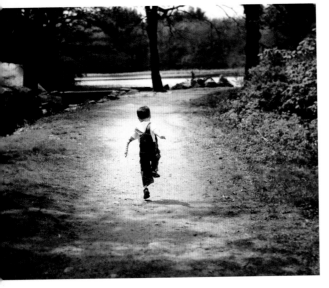

A Moment, Stopped and Remembered ⇒

The moment a one-year-old crawls down a sand-covered boardwalk to his family's beach has to be captured. They grow so fast and to have this moment stopped and remembered in a photograph, will keep that memory fresh.

SPECS > Canon EOS 1D Mark III, 70-200 at 130mm, f/3.5, ¹⁄₅₀₀ second, and ISO 200.

A Timeless Feel ⇦

This six-year-old boy was helping during his session by picking up the suitcase he had been sitting on. Just as we were moving to another location in the park, he looked back to make sure we were close behind. I kept shooting. It was a nice moment. I entered this into photographic competition titled "Travelin' Man." It has timeless feel and looks like a little man going on a trip.

SPECS > Canon EOS 5D Mark III, 135mm, f/3.5, $^1/_{500}$ second, and ISO 400.

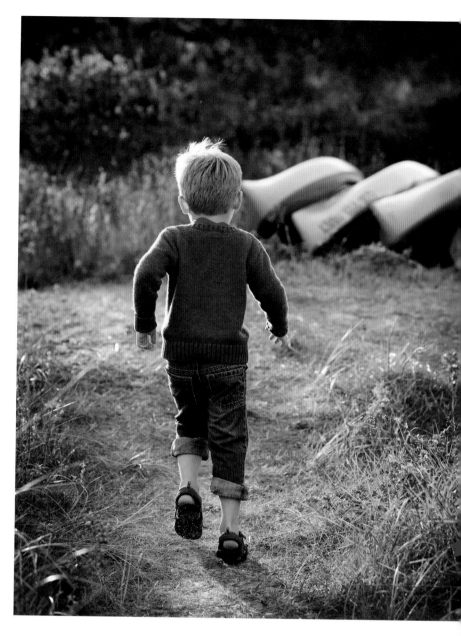

Departing Image ⇨

A departing image, whether prompted or captured as we leave a session, can add a storytelling moment to a session. The four-year-old was running off the beach at the end of the session, up the path to the house. The sunlight fell perfectly and the four boats laying in the grass added a beautiful backdrop.

SPECS > Canon EOS 5D, 70–200mm at 100mm, f/4, $^1/_{500}$ second, and ISO 250.

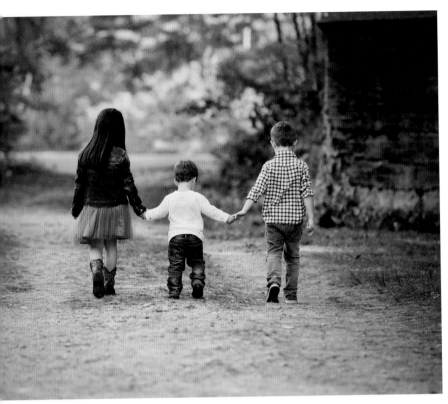

Little Walks

The older two who were five-year-old twins at the time had to keep their eighteen-month-old brother entertained during the session. Taking little walks helped to capture images of all three of them together.

SPECS > Canon EOS 5D Mark III, 70–200 at 200mm, f/4, $^1/_{500}$ second, and ISO 320.

Returning Walk

As they walk a bit, I will ask children to come back. I tell them to just enjoy their walk and its okay if you don't look at me. It really is, I don't need them smiling at the camera. If one of them does, great.

SPECS > Canon EOS 5D Mark III, 70–200 at 115mm, f/3.5, $^1/_{500}$ second, and ISO 320.

Free and Roaming ⇩

What is great with letting siblings have some free roaming time, is they will want to sit after a while. So I always have something for them to sit on. An old suitcase is one of my favorite sitting props. It can fit three children perfectly.

SPECS > Canon EOS 5D Mark III, 70–200 at 145mm, f/3.5, $\frac{1}{500}$ second, and ISO 320.

Finding That I've Made a Capture ⇪

I love when I'm looking through the images while downloading from a session and find I have captured a fun in-between moment with two siblings. As they went in for their Eskimo kiss, they started to giggle and I grabbed the moment before they held hands, nose to nose.

ECS > Canon EOS 5D Mark III, 70–200 at 142mm, f/3.5, ¹⁄₅₀₀ second, and ISO 400.

Show a Progression ⇐

Here was the Eskimo-kiss moment I was shooting for. The earlier moment was also shown as a progression of images in a slide-show to the client.

SPECS > Canon EOS 5D Mark III, 70–200 at 142mm, f/3.5, ¹⁄₅₀₀ second, and ISO 400.

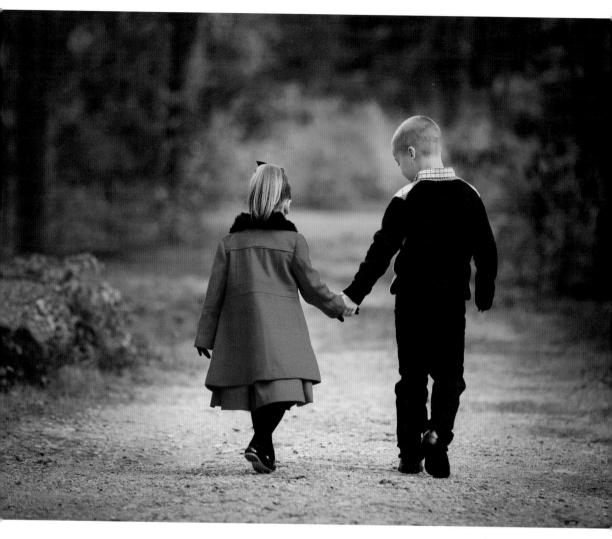

A Perfect Walking Moment ⬆

This moment, when a brother took his sister's hand as they went for a walk during the session, turned into a wonderful image. It is a perfect way to end a session. It was a late October afternoon and this particular location offered beautiful filtered light through evergreens on right, just out of frame. It is the same location that was used with the three children walking *(page 120 and 121)* just two weeks earlier. I love how much one location can change in such a short time in New England and offer a beautiful backdrop for every portrait.

SPECS > Canon EOS 5D Mark III, 70-200 at 200mm, f/3.5, $^1/_{500}$ second, and ISO 400.

Gear

I always have at least two camera bodies on me at every session. I love to switch back and forth between cameras and lenses without taking them off the bodies. I could miss a moment if I were doing that. My red wagon not only acts as a prop, but helps me carry my gear to and from the car to the park location. I always have a crate, suitcase, and blankets for parents and children to sit on. I also carry a backpack with water, batteries, extra camera body, bug spray and band-aides for those just-in-case situations.

Fill Gear for Natural Light

I utilize natural light and fill when I can with reflec-

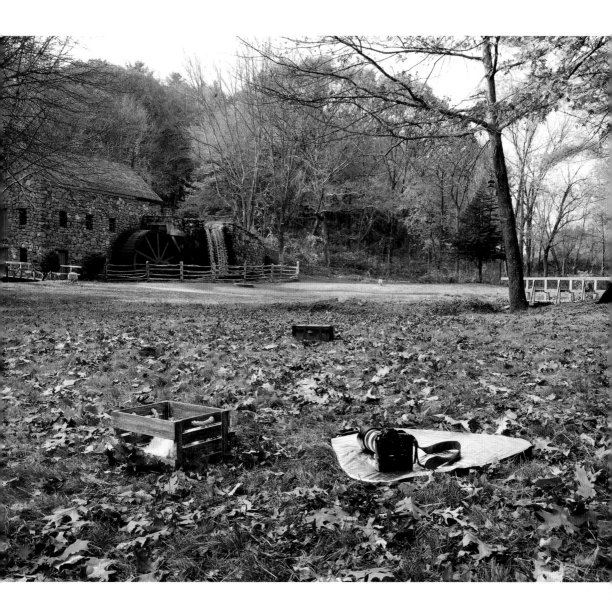

tors, so I can keep the action and expressions as organic as possible. Kids on the go won't always stay where the light is, so as a photojournalist I needed to learn how to read light and compensate quickly. Here is one of my favorite setups at a local park path. When the light comes in from one end or the other path, I will use this large reflector that will stand up and place the wagon in the spot I want the children or family to be.

A Tri-Grip Reflector and a Place to Sit

The Wayside Inn Grist Mill in Sudbury near my studio offers great light all day long. You need to use some fill to compensate where it's lacking and keep moving as the light changes. I use a tri-grip reflector, and I always have something for children to sit on.

Index